Grand Canyon

VIEWS BEYOND THE BEAUTY

by Gary Ladd

GRAND CANYON ASSOCIATION

GRAND CANYON ASSOCIATION
Post Office Box 399, Grand Canyon, AZ 86023-0399

(800) 858-2808
www.grandcanyon.org

Printed in China on recycled paper using soy-based ink

Edited by Todd R. Berger and Joy Drohan
Designed by Ron Short

First Edition
12 11 10 09 08 2 3 4 5

Library of Congress Cataloging-in-Publication Data

Ladd, Gary.

 Grand Canyon : views beyond the beauty

Gary Ladd. -- 1st ed.

 p. cm.

 ISBN 978-0-938216-89-6 (alk. paper)

 1. Grand Canyon (Ariz.)--Pictorial works. 2. Grand Canyon National

Park (Ariz.)--Pictorial works. I. Grand Canyon Association. II. Title.

 F788.L33 2008

 917.91'3200222--dc22

 2007036828

Additional photography credits:

GCA/Ron Short and GCNP Museum Collection/Michael Quinn: 4 (inset bottom), 13, 18, 21, 32, 34, 39 (inset top), 39 (inset bottom), 40, 43, 46, 49, 55, 59, 67, 70

It is the mission of the Grand Canyon Association to cultivate knowledge, discovery, and stewardship for the benefit of Grand Canyon National Park and its visitors. Proceeds from the sale of this book will be used to support the educational goals of Grand Canyon National Park.

CONTENTS

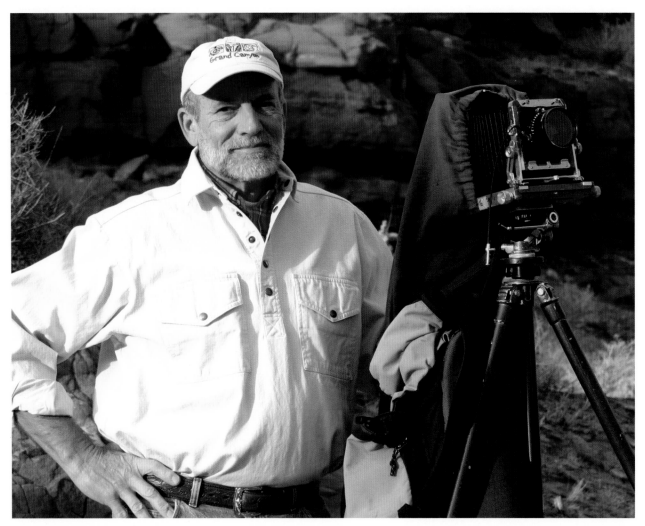

Author and photographer Gary Ladd

ACKNOWLEDGMENTS

NOT MUCH ABOUT THE GRAND CANYON IS INTUITIVE. Therefore, there is much "investigation" in progress within the canyon. Scientists continue to puzzle over the complete story of the canyon's creation, as well as its biology and human history. Backpackers poke into virgin territory at the edge of human tolerance for isolation, ankle-twisting terrain, and heat. River runners are still trying to assemble a repeatable, bombproof run through Lava Falls Rapid. There is a lot to know about the canyon and likely still much to discover, because there is far more to the Grand Canyon than is at first evident, its spectacle having proven to be a subtle and cleverly disguised invitation to look deeper.

Many "canyon heads" have inspired and nurtured my passion for and participation in the Grand Canyon cosmos. I want to thank Eber Glendening, who first probed deep into Grand Canyon many decades ago and later introduced me to the heartbreaking beauty of Grand Canyon's wayward sibling, Glen Canyon, and the splendid slickrock maze that lies beyond the reach of Lake Powell. I wish to thank again and again George Steck for some of the finest days of my life while backpacking George's barely discernable, not-even-close-to-reasonable pseudo-routes. And I want to recognize Jim DeVeny, who was willing to run the Colorado in a wooden dory back when neither of us knew what the devil we were doing. Sadly, all three of these wonderful friends have passed away in the last few years, and my life has been far less interesting and much, much the poorer since.

Of repeated help, not just for this book project but for all manner of miscellaneous musings, has been Mike Anderson, Grand Canyon National Park's recently retired trails archeologist. I also wish to thank the staff of the Grand Canyon Association, including Brad Wallis, GCA's executive director; Pam Frazier, former deputy director and longtime friend; Ron Short, art director and this book's designer, whose breathtaking work can aid and flatter the intent and effectiveness of any book he works on; and Helen Thompson, public relations director, a valued friend and an inordinately speedy but usually forgiving hiking partner.

I would especially like to thank Todd Berger, GCA's managing editor, who endured some rough water during the assembly of what was originally seen as a simple, fast, easy project. Just as with some Grand Canyon rapids, rogue currents complicated what had first been perceived from the safety of the shore as a smooth run from entry slot to tail waves. Well, they say a near-capsize soon fashions a host of fond memories.

I have been extremely fortunate to have traveled in the canyon with some of its experts—geologists, amateur historians, longtime Grand Canyon backpackers, determined day-hikers, and others—every one of them having helped in some way, intentionally or not, with the creation of *Grand Canyon: Views beyond the Beauty*. But the book was born when I asked a rookie visitor what would be most helpful in his understanding of the canyon. I wish to tip my hat to everyone who has helped me understand and appreciate the astonishing incision in the earth's surface called the Grand Canyon.

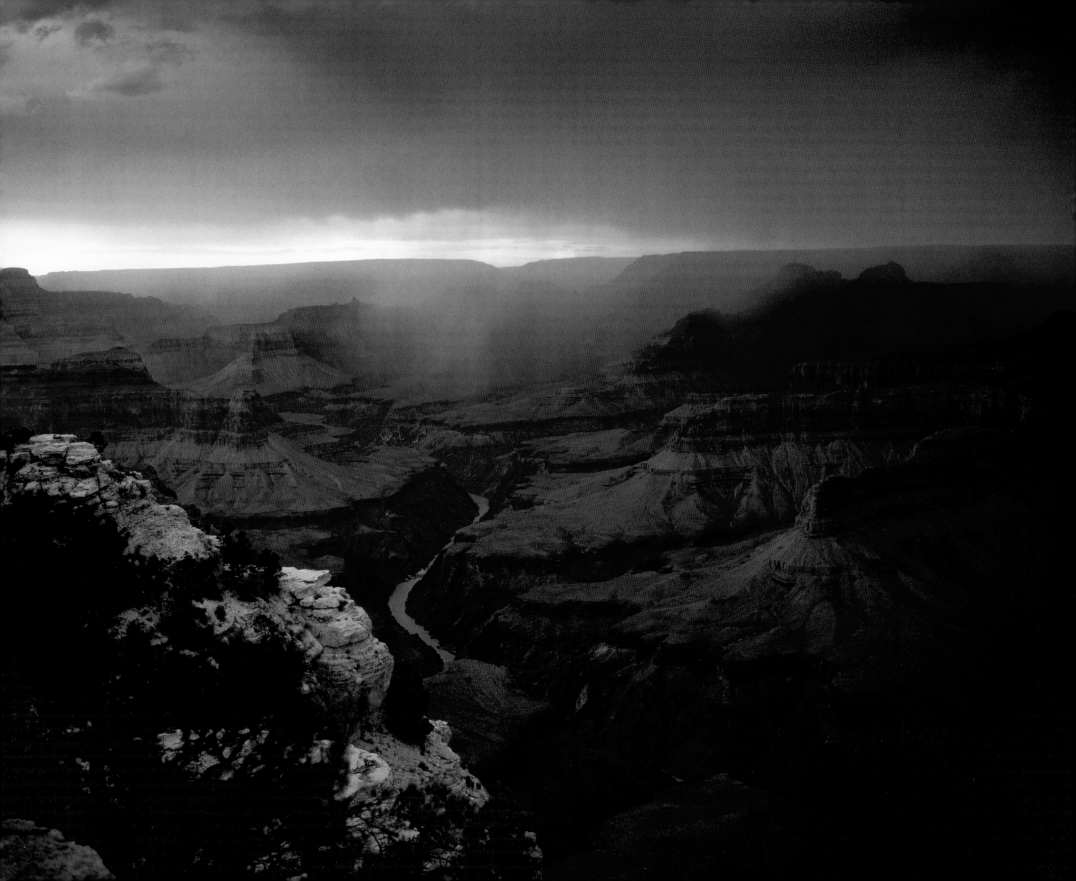

Introduction

DEEP WITHIN OUR BRAINS, HARDWIRED INTO OUR SYNAPSES, are potent attachments to the landforms of Grand Canyon. Perhaps this is due to the topography of the canyon, which resembles that of an ancient ruined metropolis dense with elegant public buildings, skyscrapers, cathedrals, theaters, apartment buildings, aqueducts, and highways. Or perhaps it is the canyon city's architectural coherence that appeals to us, as if every nuance of line and hue of every stone palace and temple were planned by a master architect. Or perhaps it is just the intrinsic drama of the canyon's overwhelming size.

Whatever the attraction, we see the cityscape from far above, as if from a dizzying catwalk, from the rim of the canyon. Looking down, we can see hundreds of square miles, from horizon to horizon, but we fail to detect much at all about what's inside.

When viewed from above, Grand Canyon is spectacle. When viewed from within, Grand Canyon is an engagement with its architecture, its atmosphere, and its history. From its rims, Grand Canyon is effect. From within, it is cause.

With this book in hand, we enter the gates of the stone city, even as we stand on the rim, to learn more about its science and history. How old are the rock layers? Who discovered the canyon? Is that a flowing stream at the bottom, a stony wash, or is it a river? How deep is it? How old is it, and how did it form? What will become of it?

When rim visitors see backpackers emerge from the Grand Canyon, they often view them as experts who have expended the time and effort to step through the rim portals into that shimmering world below. Trying to learn more about the inner canyon, they may ask, "Did you go to the bottom?," "How long were you down there?," "Did you carry all your water?," and "What's down there?"

YES, "WHAT'S DOWN THERE?" THAT'S THE REAL QUESTION.

Grand Canyon: Views beyond the Beauty ventures over the edge into the world below. It reveals the facts and contemplates canyon mysteries. The temples, peaks, plateaus, and buttes are named. The history of the canyon's many rock units are revealed. The human story comes to life. The Colorado River takes its place as the canyon's creator, and the canyon's essential facts, figures, and truths are laid open for all to see. No longer is there a need to consult the smelly backpackers emerging from the inner sanctums!

The invisible canyon—the factual heart of the canyon that cannot be seen when standing on the rim—will become apparent.

Now, whether you're visiting one of Grand Canyon's many viewpoints or lounging in an easy chair at home a thousand miles away, you have your passport into the many stone mansions below the rim. Lace up your mental boots, grab your cerebral hiking stick, hold on to your hat, and here we go.

Sunset from the South Rim's Pima Point during a mid-August monsoon downpour

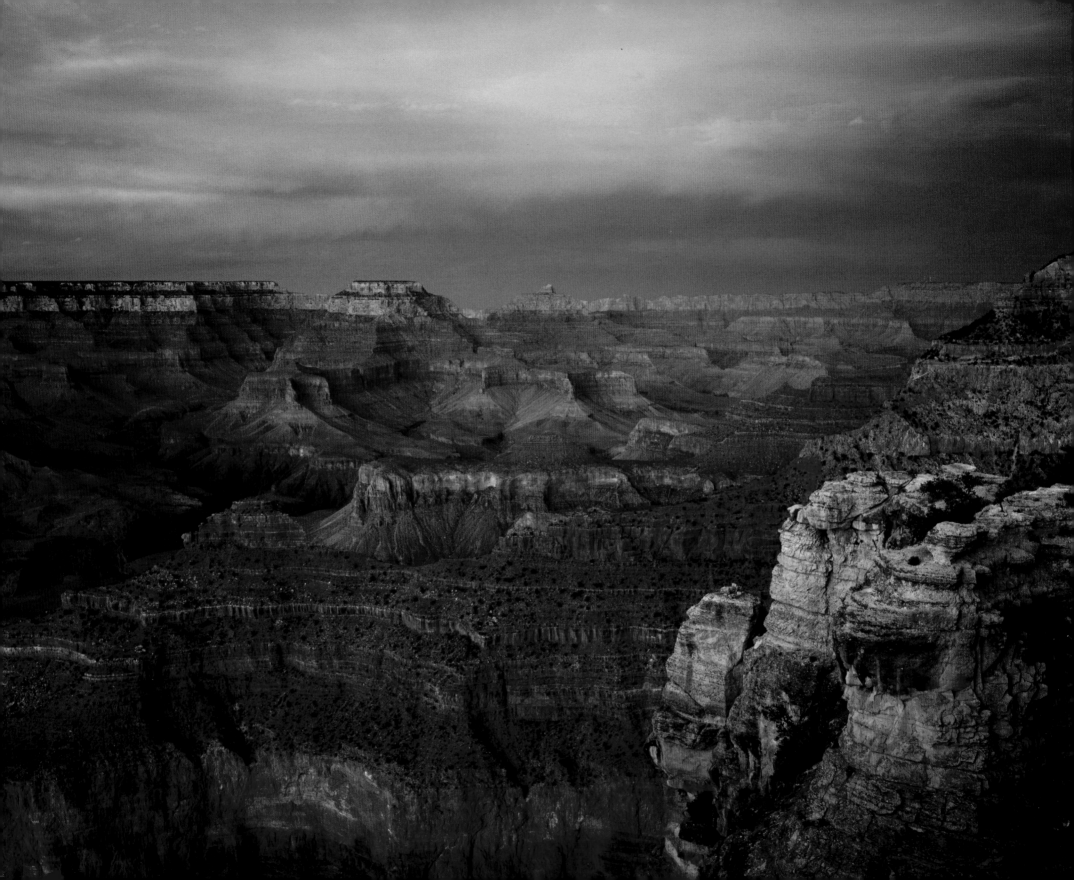

Getting Started

Grand Canyon Basics

There's a lot to know about Grand Canyon, but you can get a handle on the canyon's major concepts by reviewing this tip list.

1) **HISTORY OF THE PARK.** American Indians have lived in and around Grand Canyon for thousands of years. Europeans discovered the canyon in 1540. Grand Canyon became a forest reserve in 1893. Tourism exploded after 1901, when the railroad arrived at the South Rim. Grand Canyon became a national monument in 1908 and a national park in 1919 (seven years after Arizona became a state).

2) **THE CANYON'S SIZE.** The Grand Canyon is 277 river miles (446 km) long and averages 10 miles (16 km) wide and about a mile deep. Because the rim of the canyon is highly convoluted, it's been estimated that the number of miles of rim totals more than 2,750 miles (4,425 km). The volume of rock removed to make Grand Canyon is estimated at about 800 cubic miles (3,335 km^3). If geologists are correct, about two-thirds of a cubic foot (18,875 cm^3) of rock has been carved out of the canyon every second for six million years to make the canyon what it is today.

3) **THE CARVING OF THE CANYON.** The canyon was carved by the Colorado River, which originates in the mountains of Wyoming and Colorado. The river wears away and then carries away the canyon's rock particles. Geologists believe that the canyon deepens, on average, about an inch per century. Other processes—gravity, landslides, frost-wedging, etc.—widen the canyon and move the broken rock down the side canyons to the Colorado River.

4) **THE COLOR OF THE COLORADO RIVER.** Until Glen Canyon Dam was finished just upstream of Grand Canyon in 1963, the Colorado always flowed muddy. Today it often runs clear, the river's sand and silt having settled in Lake Powell behind the dam. But it still occasionally runs muddy if side canyons downstream from the dam are flooding. Carrying boulders and rubble to the Colorado River, floods and debris flows down the side canyons have created most of the rapids in Grand Canyon.

5) **AGE OF THE GRAND CANYON.** Most geologists believe the canyon is about six million years old. On a geologic time scale, that's only yesterday. In comparison, the canyon's oldest rock layers (at the bottom of the canyon) are at least 1.7 billion years old. Earth's age is 4.6 billion years old. A few geologists suspect that the Grand Canyon may date from far earlier than six million years ago.

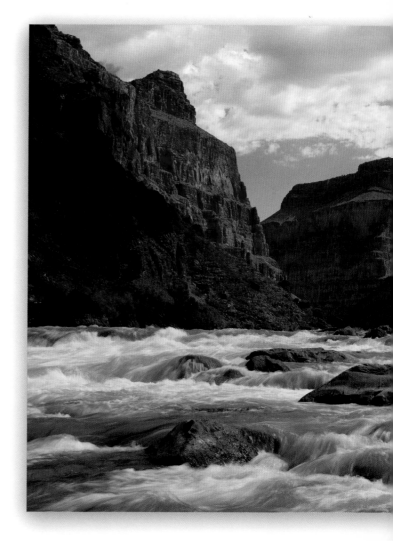

Right: Lava Falls Rapid is considered the most challenging rapid in the canyon. The Colorado often runs clear, as it does in this photograph of Lava Falls.

Opposite: Looking east from Mather Point under pastel skies

6) **ROCKFALLS AND GEOLOGIC EVENTS.** It is extremely unusual to witness any significant rockfall events as evidence that Grand Canyon continues to widen and evolve. They do occur, of course, but the canyon is so large and complex that usually no one is around to observe them. Also, most large geologic events occur during periods of extreme weather—heavy rains, freezing temperatures, and catastrophic river floods.

7) **THE RIMROCK OF GRAND CANYON.** The rimrock of Grand Canyon is the Kaibab Formation, a sedimentary limestone layer laid down on the floor of an ocean about 270 million years ago. This was, of course, long before there was a canyon here and at a time when the future Grand Canyon region lay at a much lower elevation, low enough to have been flooded by an ocean. Kaibab Limestone is extremely resistant to erosion. It was once covered by more than 5,000 feet (1,525 m) of softer rock layers, mostly sandstone and shale that were not as well suited to survive the ravages of time.

8) **NORTH RIM/SOUTH RIM RELATIVE ELEVATIONS.** The North Rim of Grand Canyon is higher than the South Rim in the most frequently visited parts of the park. The difference stems from the southward tilt of the Kaibab Plateau, the uplift through which the canyon cuts. The tilt also directs surface streams and groundwater toward the canyon on the North Rim and away from the canyon on the South Rim. The North Rim's higher elevations capture more moisture, and the toward-the-canyon plateau tilt has allowed rim erosion and recession to proceed at a faster rate there than along the South Rim. For the same reason, most of the canyon's temples have been carved from the north side of the river.

9) **RATE OF RIM RECESSION.** The rimrocks of Grand Canyon gradually fall into the canyon, causing the canyon rims to recede from the river. On average, the South Rim moves at the rate of about 2½ inches (6.5 cm) per century, the North Rim at about twice that rate. For comparison, the rimrock of Bryce Canyon in Utah, made of a poor grade of limestone, recedes at the rate of about 18 inches (46 cm) per century.

10) **GRAND CANYON VISITORS.** About 4.5 million visitors come to Grand Canyon every year, roughly 25 percent of them from outside the United States. On average, one or two people die from falls from the rim into the canyon each year. Visitors must use extreme caution. Don't venture beyond the guardrails. Never sit on the rim with legs dangling down into the canyon—getting up from that position is extremely awkward. And never turn your back to the canyon in an area without a guardrail, especially when posing for photographs.

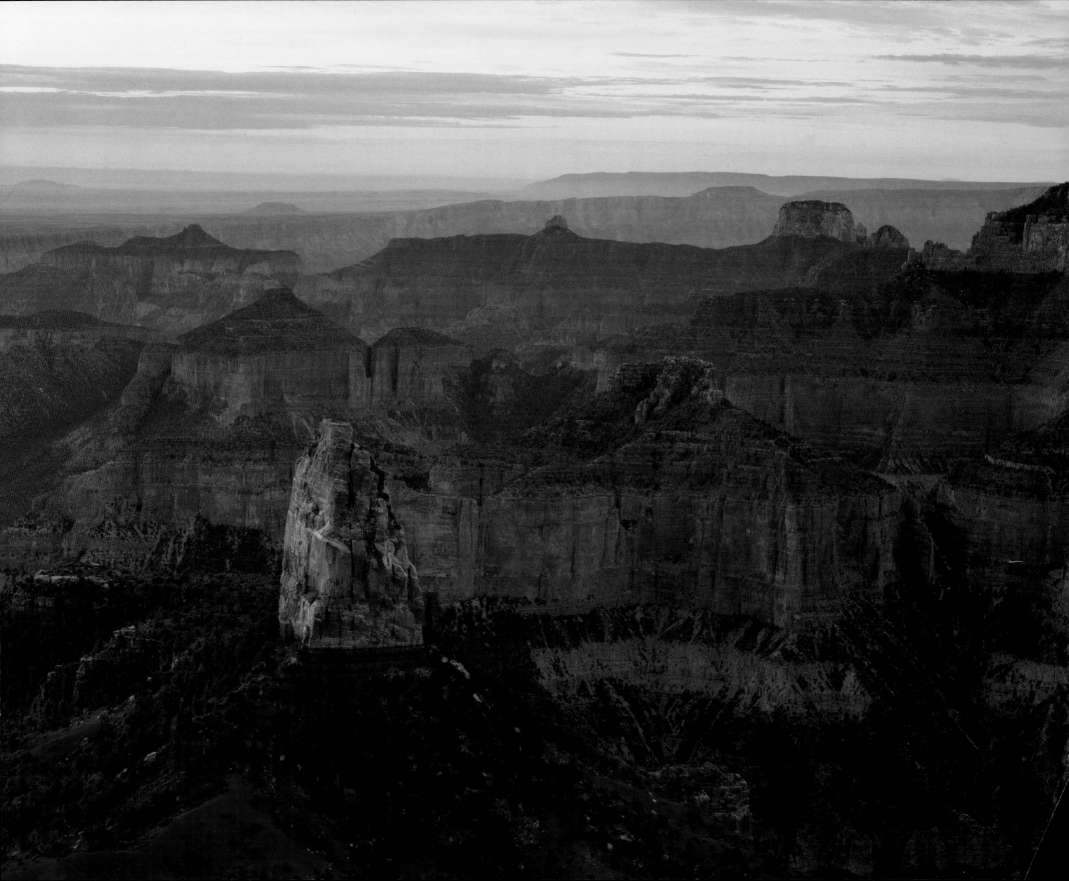

PART ONE ~ T

THE SOUTH RIM

Pima Point ~ 1

Elevation: 6,799 feet (2,072 m). Looking east on a stormy afternoon in August from River Mile 94.5 to River Mile 91

Pima Point on Hermit Road is the farthest west overlook with expansive views of the canyon. To the west of Pima, the Colorado River, hemmed in by the Inner Gorge, disappears around a bend, headed for a series of lively rapids.

Ⓐ SHIVA TEMPLE, elev. 7,570 feet (2,307 m). In 1937 an American Museum of Natural History expedition climbed to the top of Shiva Temple. The scientists hoped to find differences between the animal populations of the North Rim and those on Shiva, which presumably had been isolated from their fellows for thousands of years. The results were disappointing. Variations were almost nonexistent; as the scientists from the expedition discovered, the isolation of Shiva Temple was not absolute. They did find one notable artifact: a film box left by Grand Canyon photographer Emery Kolb, who was peeved that he had not been asked to join the expedition, and he beat the scientists to the top by several weeks.

Ⓑ UPPER GRANITE GORGE. In some sections of the canyon, the Colorado River has cut into the Vishnu basement rocks, which are at least 1.7 billion years old. This dark, ancient, highly resistant-to-erosion system of rocks confines the river to the narrow Inner Gorge, where there are few beaches and no sections broadly open to the sky. Upper Granite Gorge below Pima Point is 1,000 feet (300 m) deep—slightly more than the height of the Eiffel Tower.

Ⓒ KAIBAB UPLIFT. Geologists can easily explain the creation of the Grand Canyon if they simply say it was carved by the Colorado River. But they continue to debate the details. How, for example, did the river first grind its way across the Kaibab Uplift, a geologic bulge in the earth's surface?

Granite Rapid. In the summer, when boat traffic is at its peak, you may spot boats bounding through the rapid. You can see the rapid with the naked eye from Pima but will need binoculars to get a closer look.

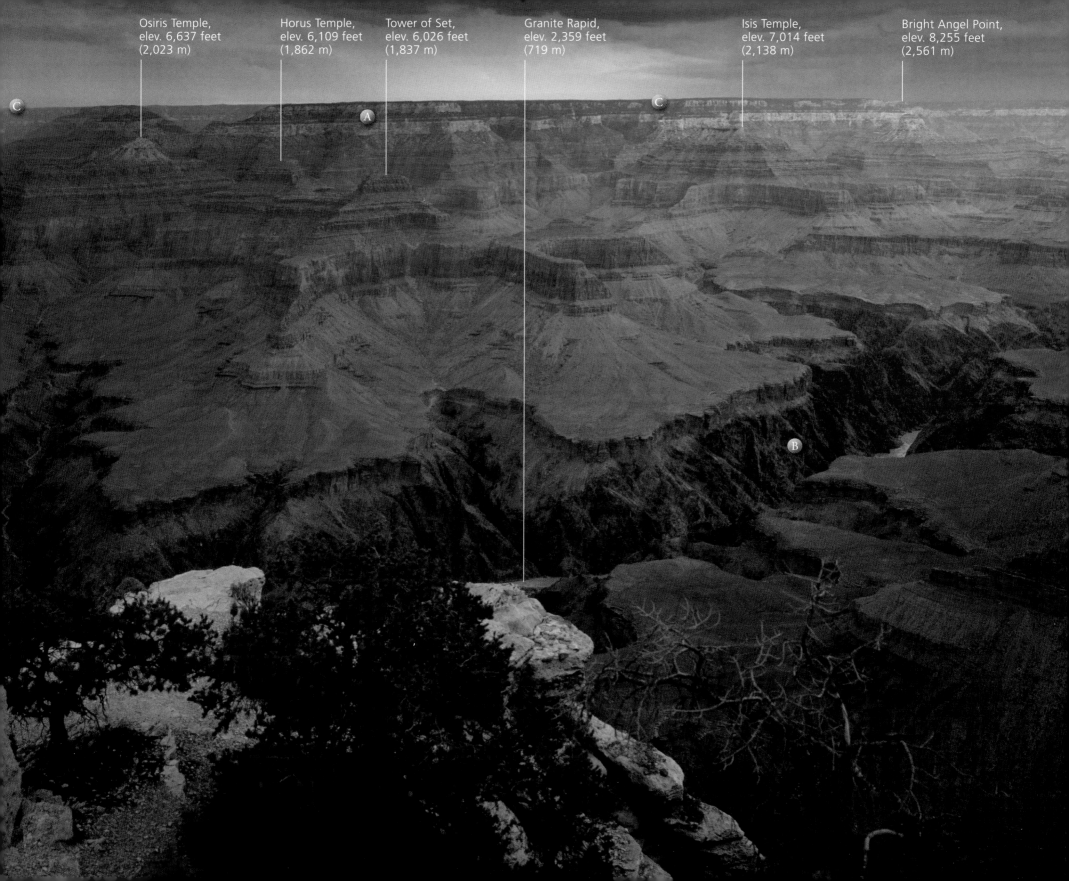

Osiris Temple,
elev. 6,637 feet
(2,023 m)

Horus Temple,
elev. 6,109 feet
(1,862 m)

Tower of Set,
elev. 6,026 feet
(1,837 m)

Granite Rapid,
elev. 2,359 feet
(719 m)

Isis Temple,
elev. 7,014 feet
(2,138 m)

Bright Angel Point,
elev. 8,255 feet
(2,561 m)

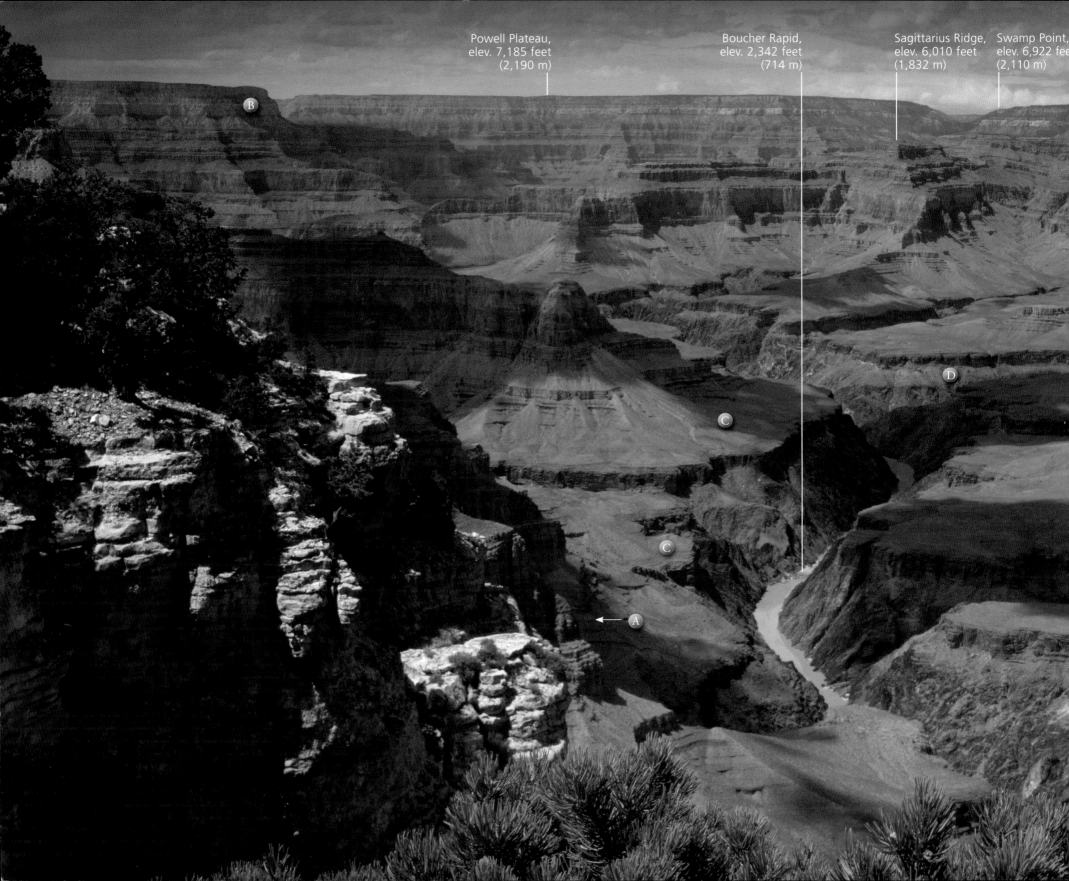

Powell Plateau,
elev. 7,185 feet
(2,190 m)

Boucher Rapid,
elev. 2,342 feet
(714 m)

Sagittarius Ridge,
elev. 6,010 feet
(1,832 m)

Swamp Point,
elev. 6,922 feet
(2,110 m)

Pima Point ~ 11

Elevation: 6,799 feet (2,072 m). Looking west on a late afternoon in August from River Mile 95 to River Mile 111

Pima Point once supported a terminus of a tramway into the canyon, in operation for some ten years in the 1920s and 1930s. Used to carry supplies to Hermit Camp, the tramway was dismantled a short time after the camp was razed in the fall of 1936.

(A) **HERMIT CAMP.** With binoculars, the ruins of Hermit Camp can be seen immediately below the overlook. The former tourist camp—including a dining hall, tent cabins, blacksmith shop, showers, and restrooms—operated from 1912 to 1930. Sections of today's Hermit Trail can also be seen below the overlook.

(B) **HAVASUPAI POINT**, elev. 6,635 feet (2,022 m). The South Bass Trail begins near this point. The trail drops nearly 4,400 feet (1,340 m) to the bank of the Colorado River over a distance of 7.8 miles (12.6 km). The trail was named after William Wallace Bass, who came to the Grand Canyon about 1884. Over a period of forty years, Bass and his wife, Ada, built a tourist camp near Havasupai Point, the South Bass Trail down to the river, a cable crossing of the river, a tourist camp on the floor of the canyon along Shinumo Creek, and the North Bass Trail up to the North Rim's Swamp Point. Today, only the two trails remain in use.

(C) **THE TONTO PLATFORM.** Erosion has stripped away the soft Bright Angel Shale, leaving a broad, flat bench that developed on top of the more resistant Tapeats Sandstone. On the south side of the river, the Tonto Trail follows this bench for ninety-five miles (153 km), including the segment seen below Pima Point.

(D) **CRYSTAL CANYON.** Crystal Rapid (at the mouth of Crystal Canyon, just beyond view in this photograph) suddenly became one of the two largest rapids in Grand Canyon after a debris flow raced down Crystal Creek Canyon in December 1966, choking the Colorado River with boulders and creating a much more violent and challenging rapid.

The Esplanade. Another broad inner-canyon bench, the Esplanade begins on the near side of the South Bass Trail and extends westward. It is perched about 1,000 feet (300 m) below the rim. In a process similar to the one that formed the Tonto Platform, the Esplanade developed where a thick sequence of soft rock, the Hermit Formation, eroded away to expose a wide expanse of the underlying erosion-resistant sandstones of the Supai Group.

Geology
of the Grand Canyon

To most people, Grand Canyon seems rather obviously old and large. It certainly possesses every visual aspect of great age and great size. But these impressions are wrong. On the epic scale of geologic time—rather than on the modest scale of human history—Grand Canyon is neither old nor large.

LET'S CONSIDER THE AGE of Grand Canyon. The rock units through which the canyon has been cut are, of course, older than the canyon itself, ranging from 1.84 billion years old at the bottom to 270 million years old on the rim. In fact, the canyon itself is not merely somewhat younger than the rock strata from which it has been carved, but far younger.

Indeed, the term "canyon" implies youth. A canyon is just a valley that's narrow for its depth. Why is the Grand Canyon narrow? Because it's young! It's so youthful that the canyon-widening processes (weathering and erosion on the rims and cliffs of the canyon) have not kept pace with the extremely active canyon-deepening processes (erosion by the Colorado River).

Exactly how old is the Grand Canyon? Not all geologists agree but most believe that a figure around six million years is about right. On Earth's geologic time scale, which reaches almost 4.6 billion years into the past, six million years is only yesterday, a little over one-tenth of one percent of Earth's history. Grand Canyon is just a child, and we are fortunate to be here to witness its formative years.

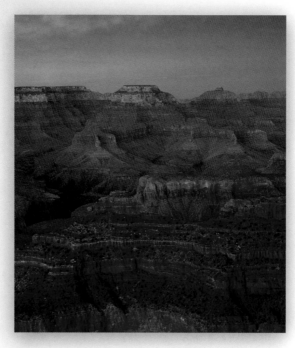

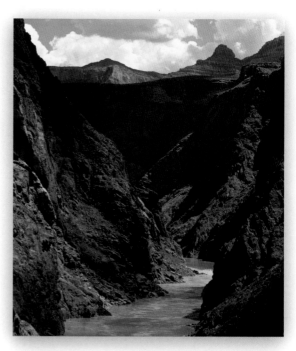

Now, consider the size of Grand Canyon. Yes, Grand Canyon does appear to be large—ten miles (16 km) wide on average, about 5,000 feet (1,500 m) deep, and 277 miles (446 km) long. But once again, on the geologic scales of time and dimension, the amount of rock carried away by the Colorado River to carve the canyon, about 800 cubic miles (3,300 km³), is rather modest. It is not difficult to find far larger erosional feats, and it is not even necessary to leave the canyon country to find evidence of them.

The thick sequence of rock exposed in the walls of the Grand Canyon is the most complete geologic record of any location on Earth. The many rock units are indisputable evidence that dozens of environments existed here before today's Grand Canyon. We know, for instance, that lavas spread their fiery devastation here, swamps once suffocated the surface here, rivers once dropped their sediments here, sand dunes once marched leeward here, and oceans repeatedly invaded and retreated here. All of this happened before there was a Grand Canyon, and all of these records are preserved in the strata of the canyon.

Most sedimentary rock layers are laid down in low areas—in and near oceans. But movements in the earth's crust can push former low-lying regions well above, sometimes far above, sea

level. That's what's happened to the Colorado Plateau, the large province through which the Colorado River is now cutting. Uplift has put an end to deposition and allowed erosion to dominate as the land surface is exposed to the ruinous effects of weather, gravity, and time. Gradually particles and pieces of the highlands fall and tumble, roll and slide, downward into ravines that lead to rivers that carry them away toward the sea, where they will be incorporated into future rock units.

The cycle of erosion and deposition tells us that the rock record of any location is never complete because periods of uplift and erosion always interrupt with periods of deposition. In Grand Canyon, like elsewhere, the majority of the sedimentary record has been lost during past erosional episodes. Geologists read the surviving record the way most of us might read an abused book from which many chapters have been torn. We know we're not privy to the entire manuscript, but we can still discern the general story and make reasonable assumptions about the missing sections of storyline.

Perhaps the most challenging Grand Canyon geologic question is, "Why is there a Grand Canyon here?" The answer is both mundane and mysterious.

It's here because a high plateau is required to provide a home for a deep canyon. And a powerful, steep-gradient river is required to cut rapidly into the high plateau. Northern Arizona has both, and, in some ways, the story is just that simple.

But if we look deeper, a mystery takes shape: There's convincing evidence at the western end of Grand Canyon that before the canyon was carved, the Colorado River did not exit the

plateau there via today's route. Where, then, did the Colorado River go before it carved Grand Canyon? To the north? To the south? Geologists are not sure.

Or maybe those are the wrong questions. Perhaps today's Colorado River is really a conjoining of two rivers. Perhaps the question should be, "Did a river to the west of today's Grand Canyon somehow capture the flow of a river northeast of the canyon, thus pirating a large volume of canyon-cutting water?" This scenario is quite possible if you remember that the earth's surface often flexes in response to deep-seated crustal movements.

One likely key to the problem is the Gulf of California, which was created about six million years ago by lateral movements along the San Andreas Fault. The gulf's creation made possible a shorter, steeper route to the ocean for any river that drained the western edge of the Kaibab Plateau (the local crustal bulge through which the canyon now cuts). The steep gradient would have allowed a vigorous river to develop on this westward slope. Perhaps, by way of headward erosion, the river could have grown eastward into the uplift, eventually capturing an ancestral, higher elevation upper Colorado River active east and north of the Kaibab.

Thus fortified with a greater volume of water and having found a shorter route to the ocean, the new Colorado River carved deep into the Kaibab Plateau, creating the Grand Canyon in a geologic moment.

One last question: If Grand Canyon is neither large nor old, and we have yet to decode its earliest history, why are we so attracted to it?

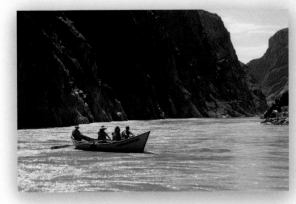

There are many reasons, all of them suggested in its name, Grand. Grand Canyon is pleasingly narrow, a canyon rather than a valley. It's a treasure trove of geologic history with rock units that are diverse in age and origin. It's orderly, displaying most of its rock units flat, little contorted by a mile and a half (2.4 km) of geologic uplift. It possesses a throbbing, powerful river at its bottom, the Colorado, the instrument of the canyon's creation. It is not overgrown by vegetation that would obscure and diminish the canyon's handsome physiognomy. And finally, it has not yet been spoiled by the activities of those pesky upstarts, human beings.

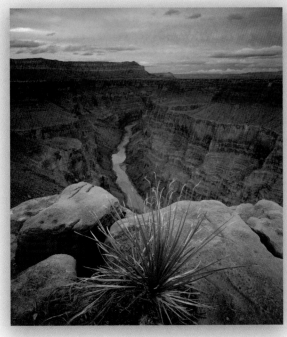

Left to right: 1) The rocks in the Grand Canyon are very old (some up to one-third as old as the earth), but the canyon itself is relatively young; 2) The Colorado River at Horn Creek Rapid; 3) The spines of a barrel cactus in western Grand Canyon. Evidence suggests the Colorado River may not have always flowed through today's western Grand Canyon to exit the Colorado Plateau; 4) The Grand Canyon that river runners travel may have been created in a geologic instant; 5) The view from the North Rim's Toroweap Overlook at sunset.

Miner's rock hammer from the Last Chance Mine on Horseshoe Mesa, which was in operation around the turn of the twentieth century

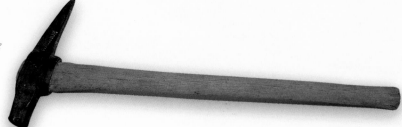

Mohave Point

Elevation: 6,995 feet (2,132 m). Looking east on a late September afternoon from River Mile 90.5 to River Mile 87

Mohave Point is named after the Mojave Tribe of the Lower Colorado River. Jutting far out into the canyon, the point can boast of fiery sunsets, as well as spectacular views of the Colorado River and the inner canyon.

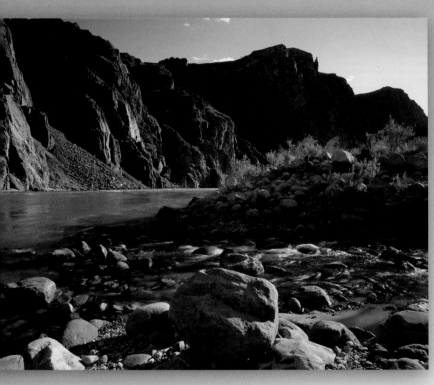

Above: Entering the Colorado River, Bright Angel Creek follows a lengthy fault up the Bright Angel Canyon to Roaring Springs, the water source for Grand Canyon National Park.

Ⓐ THE VISHNU BASEMENT ROCKS form the Inner Gorge of the Grand Canyon. These rocks are the oldest in the canyon, ranging from 1.7 to 1.84 billion years in age. Unlike any other rock unit that lies above, the Vishnu basement rocks are metamorphic, that is, they were once buried to such depths (up to five miles [8 km]) that heat and pressure modified their basic character, making them harder and highly resistant to erosion.

Ⓑ BRIGHT ANGEL CANYON. Like many tributaries of the Colorado River in the Grand Canyon, Bright Angel Canyon follows a fault line. Canyons and drainages often follow fault lines because the rock has been fractured and broken, creating weaknesses that allow flowing water to cut into the rock more effectively. Bright Angel Canyon is also home to the North Kaibab Trail.

Ⓒ NORTH RIM. The North Rim stands roughly 1,000 feet (300 m) higher than the South Rim because the Kaibab Uplift through which the canyon has been cut slopes gently southward in this area. The North Rim's higher elevations (which capture more moisture) and the southward tilt of the rock units (which directs drainages away from the South Rim) conspire to produce larger springs and bigger streams than those originating on the Colorado River's south side.

Ⓓ ZOROASTER TEMPLE. One of the Grand Canyon's most famous and prominent landmarks can be seen clearly looking northeast from Mohave Point. Crowned with Coconino Sandstone caprock, Zoroaster Temple was named in 1902 by the writer George Wharton James, after the Persian religious leader of the 5th and 6th centuries BC. The pointy-topped, 7,129-foot (2,173-m) formation, despite its prominence, was only climbed for the first time in 1958. David Ganci and Rick Tidrick completed the technical ascent in August, a rather hot and wet time to climb in the Grand Canyon.

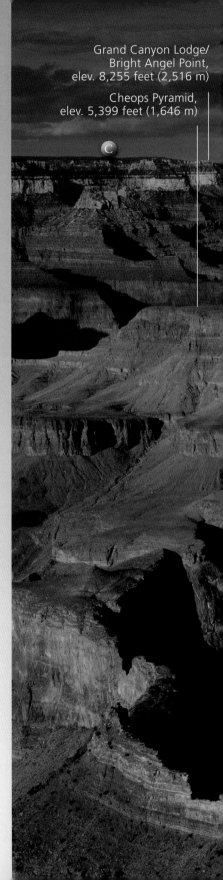

Grand Canyon Lodge/ Bright Angel Point, elev. 8,255 feet (2,516 m)

Cheops Pyramid, elev. 5,399 feet (1,646 m)

Ⓒ

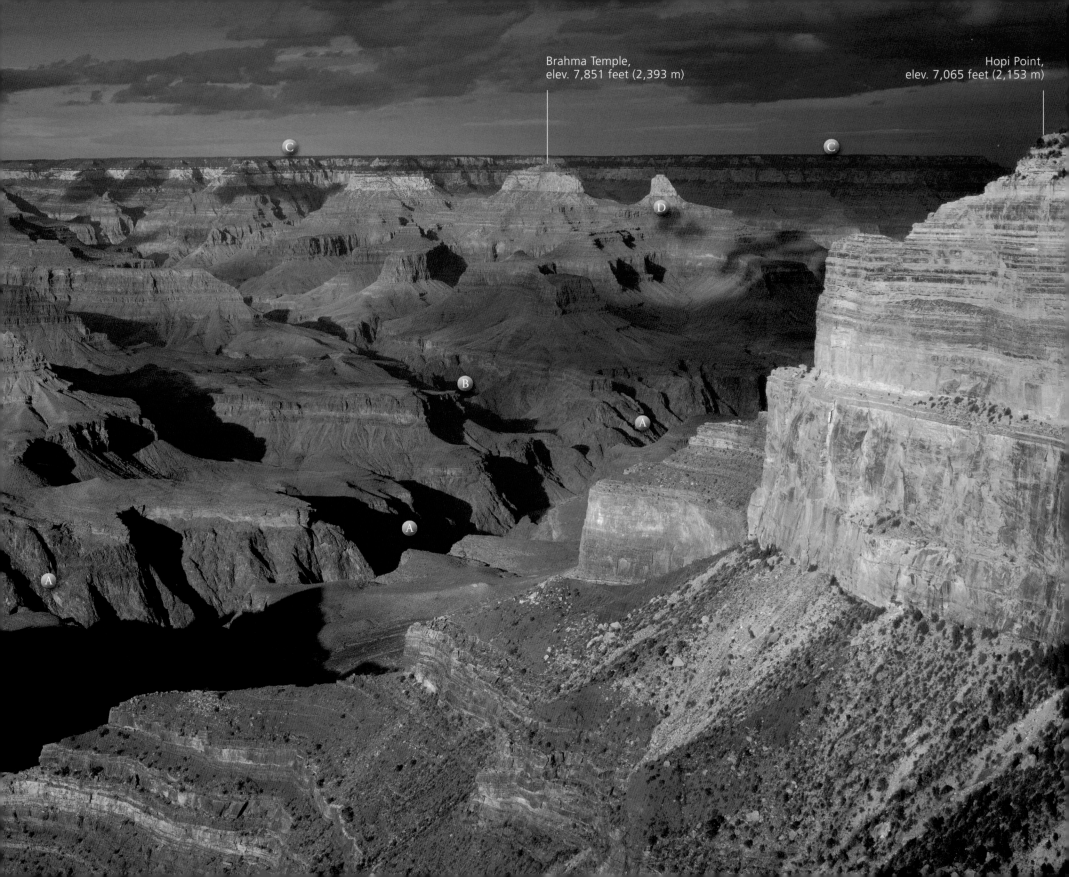

Brahma Temple,
elev. 7,851 feet (2,393 m)

Hopi Point,
elev. 7,065 feet (2,153 m)

Hopi Point ~ 1

Elevation: 7,065 feet (2,153 m). Looking west on an early morning in August from River Mile 127 to River Mile 93.5

Hopi Point on Hermit Road is perhaps the most popular overlook on the South Rim to watch sunrise and sunset. The point is named for the Hopi people of northeastern Arizona, who believe the ancestors of all humankind emerged from the earth in the inner canyon.

After an unusually wet winter and spring, brittlebrush in the inner canyon fills a talus slope with golden blooms.

A FROM HOPI POINT you can easily grasp the huge size of the flat plateau through which the Colorado River has cut to create the Grand Canyon. South of the canyon, it is known as the Coconino Plateau; north of the canyon, it is known as the Kaibab Plateau.

B GRAND CANYON ROCK LAYERS. The striped appearance of the Grand Canyon's walls—with colored layers that form alternating slopes and cliffs—are due to differing rock types. The yellowish Kaibab Formation forms the rimrock you stand on when visiting Grand Canyon overlooks, and some layers are particularly prominent as you look into the canyon, including the thick band of red about halfway down that makes up the Redwall Limestone and the black Vishnu basement rocks in the Inner Gorge. Hopi Point is a good spot to see almost all of the major rock layers in the canyon; they are named and marked on the photograph.

C WHEELER POINT, elev. 6,721 feet (2,049 m). This point is named after George M. Wheeler, who explored the western Grand Canyon by river in 1871. He employed several Mojaves to drag, row, and pole three boats two hundred miles (320 km) up the Colorado to the mouth of Diamond Creek in western Grand Canyon.

D COLORADO RIVER. Glen Canyon Dam normally releases water drawn from far below the surface of its reservoir, Lake Powell. Thus, today, unlike in the summers before the erection of the dam, the Colorado River is always cold, even in summer—usually between 47 and 53 degrees Fahrenheit (8–12°C). The cold water is a boon to summer river runners who must endure air temperatures of 100 to 115 degrees Fahrenheit (38–46°C).

Coconino Plateau

Cope Butte,
elev. 4,508 feet (1,374 m)

The Alligator,
elev. 5,810 feet (1,771 m)

Havasupai Point,
elev. 6,635 feet (2,022 m)

Great Thumb Mesa,
elev. 6,749 feet (2,057 m)

A

C

Kaibab Formation

Toroweap Formation

Coconino Sandstone

Hermit Formation

Supai Group

Bright Angel Shale

Tapeats Sandstone

Redwall Limestone

Muav Group

B

Vishnu Basement Rocks

B

D

Hopi Point ~ 11

Elevation: 7,065 feet (2,153 m). Looking east on a late afternoon in August from River Mile 88.5 to River Mile 68

Many visitors come to Hopi Point for sunrise and sunset because of its sweeping, panoramic views of the canyon. If any part of the sky turns radiant with the rising or sinking sun, Hopi invariably offers a great vantage point.

Zoroaster Temple, elev. 7,129 feet (2,173 m)

Brahma Temple, elev. 7,851 feet (2,393 m)

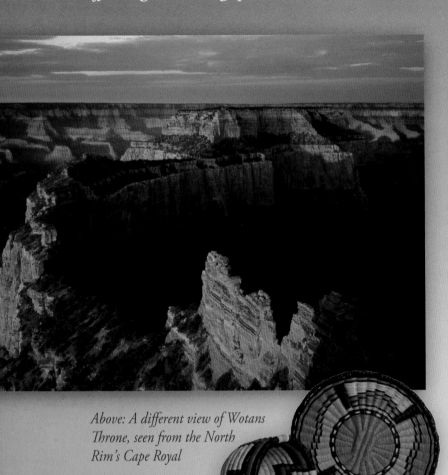

Above: A different view of Wotans Throne, seen from the North Rim's Cape Royal

Hopi baskets collected by Grand Canyon National Park naturalists Eddie McKee and Louis Schellbach in 1934

A PLATEAU POINT, elev. 3,860 feet (1,177 m). This Tonto Platform viewpoint overlooks the Colorado River, more than 1,400 feet (430 m) below. Plateau Point can be reached on foot by following the Bright Angel Trail and then the Plateau Point Trail, a one-way hike of 6.1 miles (9.8 km). Single-day mule trips also make the journey to Plateau Point—and back.

B CAPE ROYAL, elev. 7,865 feet (2,397 m). Cape Royal stands at the southern tip of the North Rim's Walhalla Plateau. The overlook offers an astonishing panoramic view of eastern Grand Canyon

C VISHNU TEMPLE, elev. 7,829 feet (2,386 m). Only a few dozen people have ever stood on the summit of Vishnu Temple. The climb is not difficult, but the route to its base is long and complex.

D O'NEILL BUTTE, elev. 6,071 feet (1,850 m). The South Kaibab Trail passes on the far side of this butte. Unlike most Grand Canyon trails, the South Kaibab follows a ridge, granting its hikers spectacular views of the canyon.

E MONSOON CLOUDS. By mid-July in most years, moisture, pulled up from Mexico, arrives in the Grand Canyon region on prevailing winds from the south and southeast. Clouds condense over the canyon, and what are known as "monsoons" commence, bringing afternoon thunder, lightning, wind, and downpours. Lightning strikes and flash floods can be very dangerous during monsoon season. Stay clear of the rim if there is a thunderstorm in the area, and do not hike in slot canyons if there is any chance of rain in the region. The monsoons occur sporadically until they dissipate in mid- to late September.

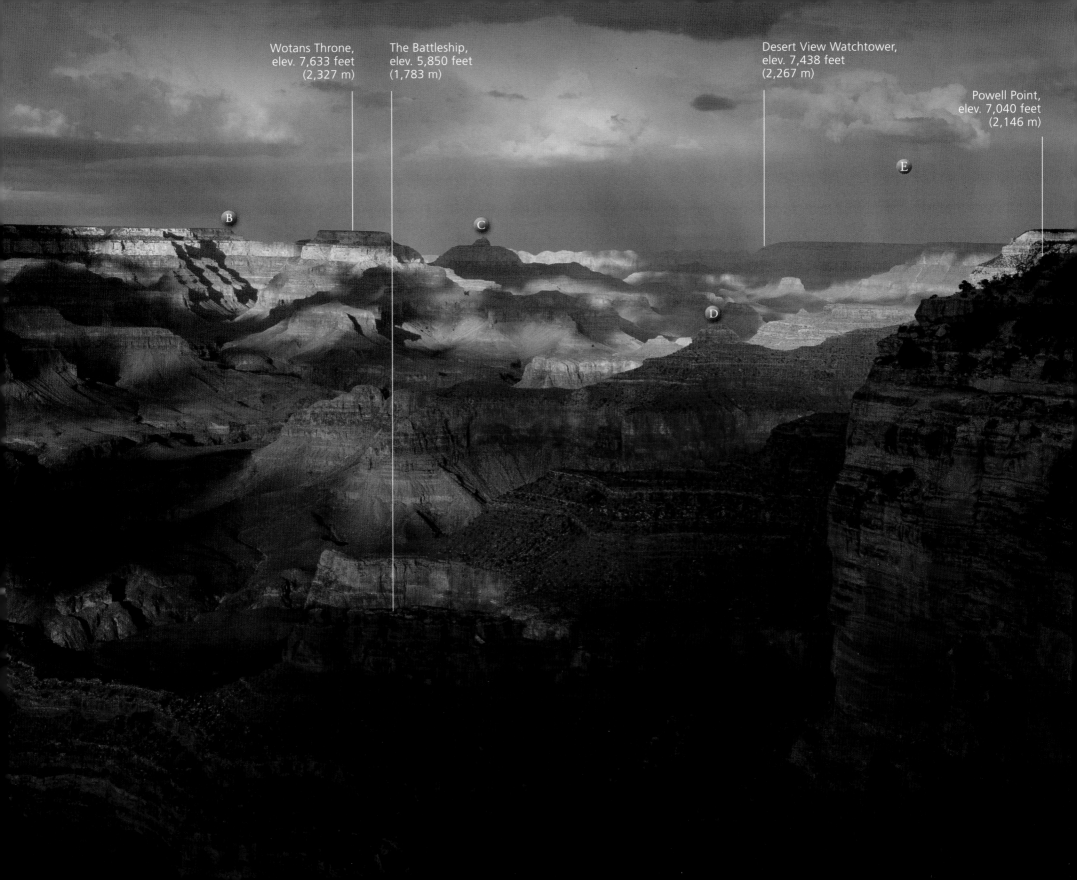

Wotans Throne,
elev. 7,633 feet
(2,327 m)

The Battleship,
elev. 5,850 feet
(1,783 m)

Desert View Watchtower,
elev. 7,438 feet
(2,267 m)

Powell Point,
elev. 7,040 feet
(2,146 m)

Grand Canyon's Trail System

The Grand Canyon is a three-dimensional maze with time constraints imposed by scarce water sources. Cliff-forming rock layers strictly limit the number of rim-to-river routes while distances between water sources limit lateral travel through the canyon. Backpackers don't often get lost in the Grand Canyon, but they can get caught in a snare of overwhelming size, rugged terrain, and scarce water.

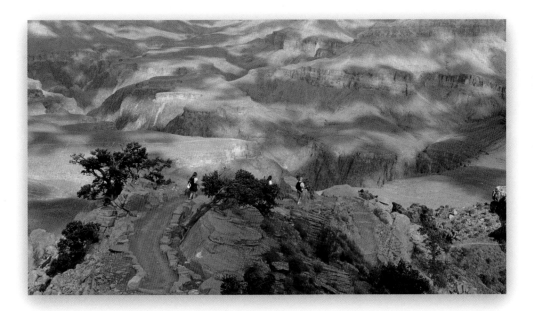

Left: Day hikers descend the South Kaibab Trail. The trail follows a ridge over much of its length, providing panoramic views of the canyon.

Right: The 1928 Kaibab Suspension Bridge carries hikers and mules over the Colorado River.

Opposite: A hiker on the inner canyon's Tonto Trail, which winds ninety-five miles (153 km) from Hance Rapid to Garnet Canyon.

OVER THE PAST CENTURY, a series of trails has been constructed into and through some sections of the Grand Canyon. Some of the trails are improvements on ancient American Indian routes. Others have been made possible only with the help of high explosives and jackhammers. The majority of Grand Canyon's trails are located below the South Rim's paved roads from Desert View to Hermits Rest. A few others are located on the north side of the Colorado River below the paved North Rim roads. And a handful more are located farther west.

The most well-known, most used, and best maintained trails are the Bright Angel, the North Kaibab, and the South Kaibab in the section of the canyon known as the Corridor. Like most Grand Canyon trails, they lead from the rim to the river, and they all converge on Phantom Ranch.

Other rim-to-river trails are not routinely kept in such good repair. When rockfalls and washouts damage them, it's often up to hikers and backpackers to safely find their way across the damaged sections. Such trails include the Boucher, Hermit, Grandview, New Hance, and Tanner trails, which all descend from the South Rim's paved roads. Most run eight to ten miles (13–16 km) from rim to river. The great advantage of using these and

the Corridor trails is that they are connected to one another within the canyon by the Tonto Trail (or in the case of the Tanner Trail, by the Escalante Route), which roughly parallels the river, weaving in and out of side canyons along the way. Rim-to-river trails in combination with the Tonto Trail make many loop trips possible.

The North Rim offers the North Kaibab Trail (to Phantom Ranch and the Colorado River, including a junction with the Clear Creek Trail that heads east into Clear Creek Canyon) and the Nankoweap Trail. Farther west via primitive roads, the North Bass and South Bass trails reach opposite banks of the Colorado River. There is no bridge to cross the river and connect the trails. Still farther west are the trail to Supai, a village on the Havasupai Indian Reservation below the South Rim and, on the north side, the Thunder River Trail and the Lava Falls Route.

There are a few other so-called trails that are more like feasible routes that must be followed by using detailed maps and a great deal of caution.

Backpackers often begin their Grand Canyon hiking careers on one of the Corridor trails—the North Kaibab, South Kaibab, or Bright Angel trails. If all has gone well on

these trips, later hikes may include one of the nonmaintained trails. With yet more experience, backpackers may choose to follow off-trail routes through remote sections of the Grand Canyon. As permits are required, check with Grand Canyon National Park's Backcountry Information Center if you have an interest in backpacking any of the inner canyon trails.

Hiking boots of Harvey Butchart, Grand Canyon trailblazer, who is said to have spent more time hiking in the inner canyon than any other person

Powell and Maricopa Points

Looking east from Powell Point, elev. 7,040 feet (2,146 m), to Maricopa Point, elev. 6,995 feet (2,132 m), on an August morning from River Mile 85 to River Mile 68

Powell and Maricopa points perch on the rim shoulder to shoulder. Powell Point was named for John Wesley Powell, the leader of the 1869 river expedition, the first to explore Grand Canyon by boating down the Colorado River. Maricopa Point was named in honor of the Maricopa Tribe of central Arizona.

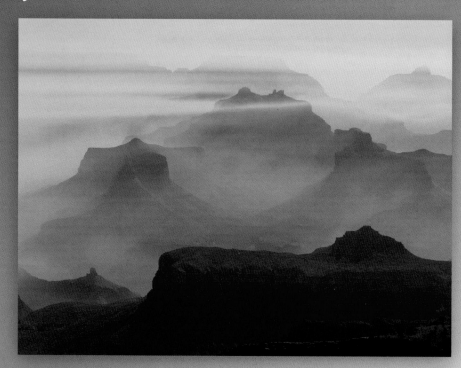

Haze in the canyon is common, and it is especially noticeable while looking toward the sun. Some haze is natural, becoming more prominent on windy days, when smoke drifts in from forest fires, or when humidity is high. However, pollution from metropolitan areas, power plant smoke, and other human-induced sources also contribute to the haziness at Grand Canyon. This photograph shows smoke drifting through the canyon from a North Rim wildfire.

A ORPHAN MINE. The ruins of the Orphan Mine (just out of range of the photograph to the right) are nestled between Maricopa and Powell points. The uranium mine operated between 1956 and 1969. The entrance to the mine's vertical shaft can be seen some 1,000 feet (300 m) downslope from the headframe on the rim. The National Park Service oversees the mine, and the potentially dangerous site is closed to visitors.

B THE RIM of the Grand Canyon is sharply defined and completely unambiguous. Canyons that cut through mountains offer no precise rim. The Grand Canyon's rim is explicit because the Kaibab Formation rimrock is extremely resistant to erosion while the rock unit that once rested on the Kaibab, the Moenkopi Formation, is very soft and has been washed away by erosion. This left behind a precise, sudden drop-off without the complexities of slopes, swales, and peaks along the canyon's perimeter.

C DESERT VARNISH, a dark patina often seen on the canyon's cliffs, forms only in arid climates and is most prominent where water occasionally trickles down cliff faces. The varnish consists mostly of fine windblown clay particles that adhere to wet surfaces. Iron and manganese oxides, carried by the clay particles, give the coating much of its dark color. Living matter—bacteria, for instance—also plays a part in desert varnish development.

Wotans Throne, elev. 7,633 feet (2,327 m)

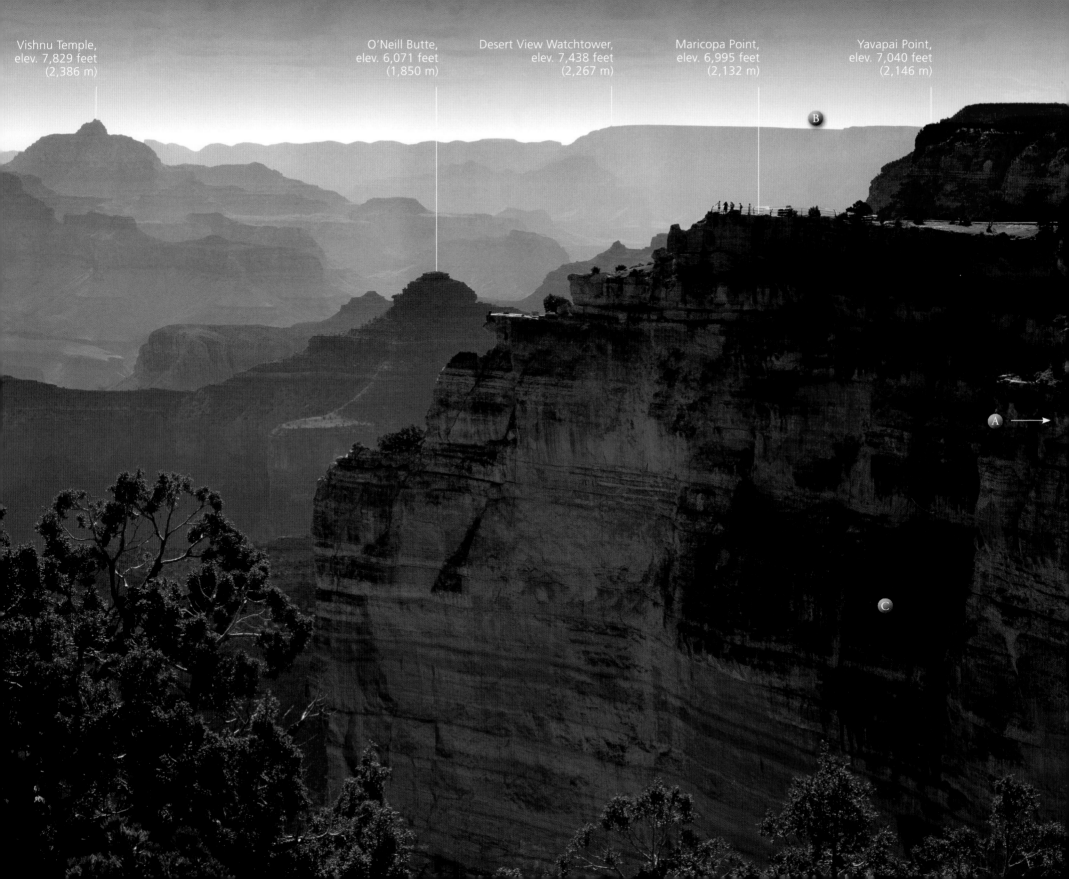

Vishnu Temple,
elev. 7,829 feet
(2,386 m)

O'Neill Butte,
elev. 6,071 feet
(1,850 m)

Desert View Watchtower,
elev. 7,438 feet
(2,267 m)

Maricopa Point,
elev. 6,995 feet
(2,132 m)

Yavapai Point,
elev. 7,040 feet
(2,146 m)

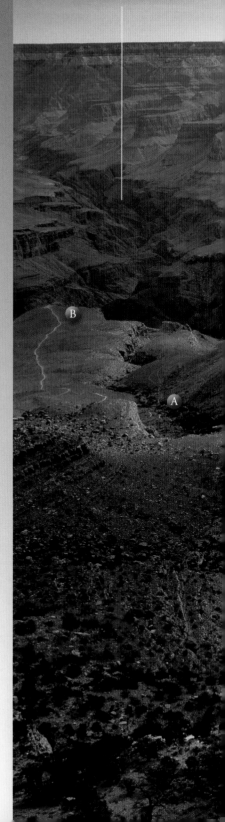

Trailview Overlooks

Elev. 6,970 feet (2,124 m). Looking northeast on a late morning in August from River Mile 89 to River Mile 84

The Bright Angel Trail twists down into Grand Canyon headed for Indian Garden and the Colorado River. Watch for hikers and mule trains making their way through the switchbacks.

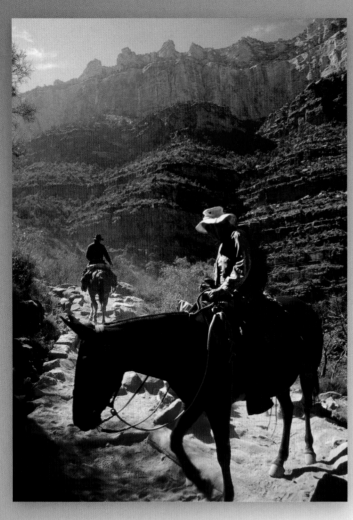

Ⓐ INDIAN GARDEN. To the left, much of Indian Garden—which includes a rest stop, campground, and year-round water supply—is visible. Farther up the Bright Angel Trail toward the South Rim, both Three-Mile Resthouse (at the top of the Redwall Limestone cliff) and the restrooms just below Mile-and-a-Half Resthouse (near the top of the sloping Supai Group) are visible. Look for happy hikers rambling down the trail and tired hikers trudging up the trail.

Ⓑ PLATEAU POINT, elev. 3,860 feet (1,177 m). Plateau Point is 6.1 miles (9.8 km) from the South Rim via the Bright Angel and Plateau Point trails. The overlook offers fine views of the Colorado River more than 1,400 feet (430 m) below, flowing through the depths of Upper Granite Gorge. In 1922 an airplane landed on the Tonto Platform near Plateau Point. Ellsworth Kolb masterminded the publicity stunt.

Ⓒ THE BRIGHT ANGEL TRAIL, which follows the route of an ancient American Indian trail, was improved in 1891. It is 4.6 miles (7.4 km) from the rim to Indian Garden, an additional 3.2 miles (5.1 km) to the Colorado River, and still another 1.5 miles (2.4 km) to Bright Angel Campground near Phantom Ranch. In its early years, the trail was controlled by Ralph Cameron, who charged all mule and horse riders one dollar per animal. At that time, very few people used their feet to travel into the canyon.

Ⓓ GRANDEUR POINT, 7,037 feet (2,145 m), offers peaceful—but still spectacular—views of the inner canyon. The point is only accessible via the Rim Trail or via a spur trail from Park Headquarters, and its secluded location is not near any roads or parking lots. The paved trail to the point is an easy, level walk heading either east from Grand Canyon Village, west from Yavapai Point, or north from Park Headquarters.

Left: Mule riders ascend the Bright Angel Trail. Trailview Overlooks loom on the horizon.

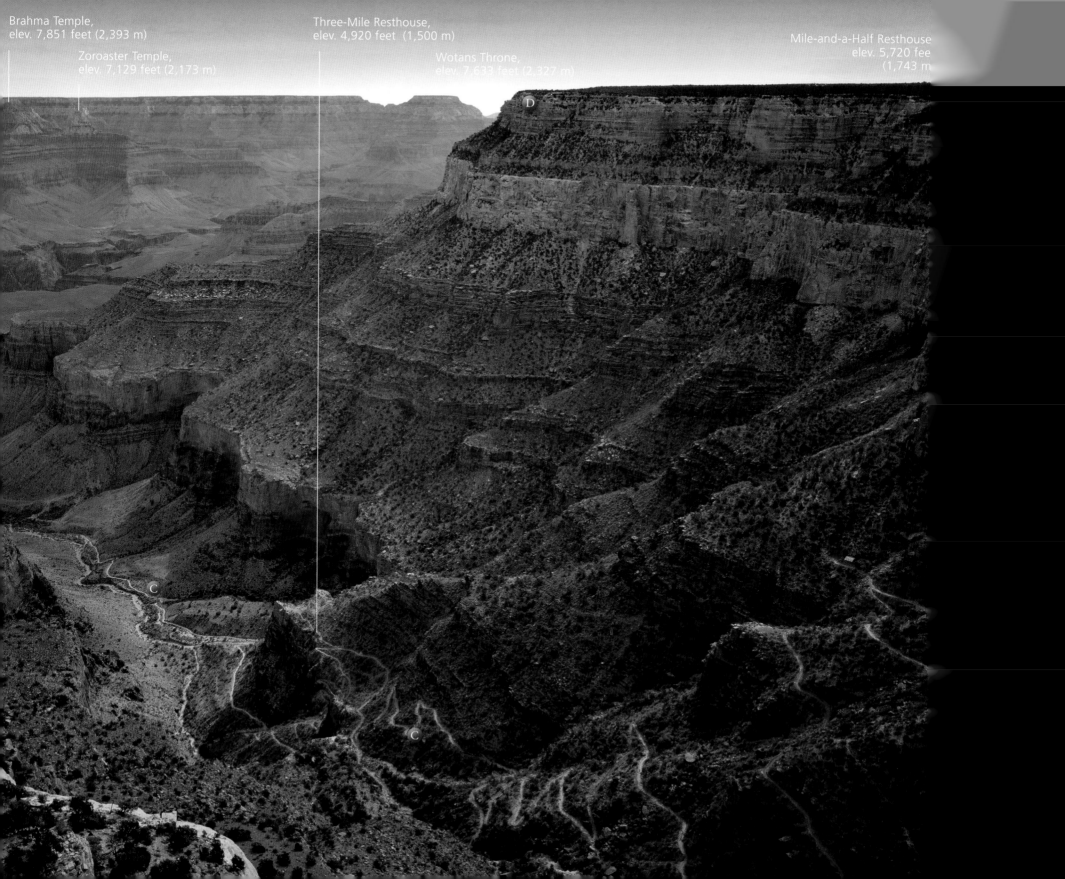

Brahma Temple,
elev. 7,851 feet (2,393 m)

Zoroaster Temple,
elev. 7,129 feet (2,173 m)

Three-Mile Resthouse,
elev. 4,920 feet (1,500 m)

Wotans Throne,
elev. 7,633 feet (2,327 m)

Mile-and-a-Half Resthouse
elev. 5,720 fee
(1,743 m

Photography

Most of us want to record images of this world-class landscape. Here are a few suggestions on how to create effective Grand Canyon photographs.

*One of
Gary Ladd's
4 x 5 cameras*

1. **TIME OF DAY.** As you might expect, the hour before and during sunset, and the hour during and after sunrise, are often the most visually dramatic. If the sky is clear, this is especially true; in comparison, midday on a cloudless day is disappointingly stark. The warm colors and low-angle light of sunrise and sunset flatter the canyon's multicolored topography.

2. **CLOUDS.** Anytime there are clouds, canyon photography is improved. Clouds lend interest to an otherwise dull sky, they radiate light that adds detail in the shadows of cliffs and mesas, and they cast shadow patterns on the landscape that otherwise camouflage the huge distances tucked into the canyon. In addition, they can fashion dramatic light beams that can accentuate otherwise obscure canyon features, shield from sunlight huge volumes of air that would otherwise appear hazy with dust and water vapor, flood the canyon with color, and reveal streamers of rain. Clouds make possible thousands of different photographs from each overlook. If there are clouds over the canyon during your visit, be happy!

3. **FILTERS.** When photographing expansive sections and long distances within the Grand Canyon, a warming filter is important. Dust and water vapor in the air scatter the blue end of the spectrum more efficiently than the red end. So, when looking over long distances—five, ten, twenty, fifty miles—we see an abundance of blue wavelengths that have been rerouted by the dust in the air, blue wavelengths that diminish the pleasingly warm colors of the canyon. To combat this problem, I almost always use an 812 warming filter when photographing the canyon from the rims. Before sunrise and after sunset on some occasions, I'll use either a KR3 or a KR6 warming filter to combat the strong blue cast that dwells within the depths of the canyon. I also sometimes use a polarizing filter (which reduces glare from reflective surfaces, including water vapor and other particles in the air) when its effect appears desirable, and a graduated neutral density filter (which reduces the difference in brightness between the sky and the ground without affecting color) to help balance high-contrast scenes.

4. **FOREGROUNDS.** Often a photo of Grand Canyon is improved when a foreground feature is included in the frame. A tree, a group of people, or a projecting rimrock can lend depth, interest, and a fresh palette of colors to the photograph. People in the foreground are especially effective because they offer a sense of scale to scenes with dimensions that are difficult to quantify. It must be remembered, however, that adequate depth of focus must be used when including any foreground object. Adequate depth of focus requires the use of smaller apertures, which lead to the employment of longer exposures. Such exposures often require the use of a tripod.

5. **PATIENCE.** Most fine landscape photographs include an element of patience in their capture. By looking for an improved foreground, by waiting for better light, by using a tripod for greater depth of focus and careful composition, by purposely looking longer and deeper into the scene, by considering all the possibilities of composition and timing, generous dividends are obtained. If you are serious about making good photographs, you'll have to invest considerable time.

6. **PITFALLS.** Try to break free of unintentional self-imposed stumbling blocks and limitations. There are many:

- Carry enough film (or gigabytes of memory) and extra batteries.

- Hold your camera as steady as possible, or, better yet, use a tripod.

- If your camera equipment includes a zoom lens or interchangeable fixed lenses, fit the focal length to the situation by eliminating picture elements that don't add to the impact of the image.

- Consider both horizontal and vertical formats.

- Unless the day's clouds are of special interest, don't surrender more than a quarter or a third of the frame to the sky—this is especially important when the sky is clear.

- In most cases avoid centering the scene's dominant feature. Place it about a third of the way into the scene.

- Unless the sky is inhabited by handsome clouds, the best photographs are usually captured in the hour after sunrise and in the hour before sunset.

- At sunrise and sunset, don't forget to consider all directional possibilities: looking toward the sun, looking away from the sun, and looking in directions in between.

7. **PEOPLE.** If you wish to take pictures of a person or a group of people standing on the rim of the Grand Canyon, do these things: Have them face you with the overlook railing behind them. (Do not ask them to stand with their backs to the canyon where there is no protective railing.) Move close enough to them so they fill one-third to two-thirds of the frame. (Get close enough to the person or group to easily see their faces.) Be sure that the active auto focus sensor is placed on the figures, not the canyon (otherwise your friends or family will be out of focus). Consider using fill flash on bright, clear days when photographing into the sun. (The flash will help illuminate the shadow areas on those who are backlit by the sun).

8. **RELAX.** This is the Grand Canyon. The Grand Canyon! Don't spend all of your time tinkering with your camera; look around and enjoy the atmosphere.

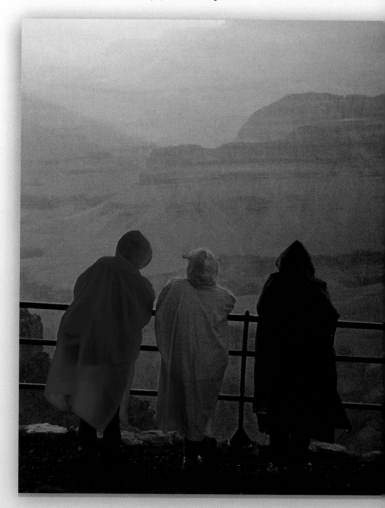

Above: Sometimes, colorful people photographs present themselves in unexpected ways.

Left: The flowering stalk of an agave adds depth to this shot of the canyon under monsoon skies.

Opposite: Unusual March cloud cover changes the light and adds colorful elements to the view east from Pima Point.

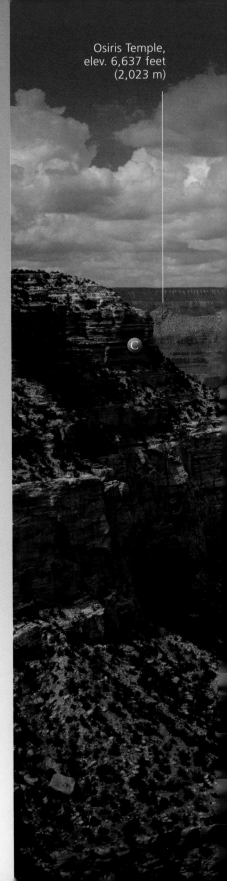

Grand Canyon Village

Elevation: 6,860 feet (2,091 m). Looking northwest on an early afternoon in August from River Mile 91 to River Mile 89.5

In many ways, Grand Canyon Village is the heart of Grand Canyon's rim world. It's where the famous Bright Angel Trail begins its descent to Phantom Ranch, it's located near where the canyon attains its greatest depth, it's where the railroad comes to the canyon, it's by far the most popular canyon visitor destination, and, not surprisingly, it lays at one's feet many fine canyon views.

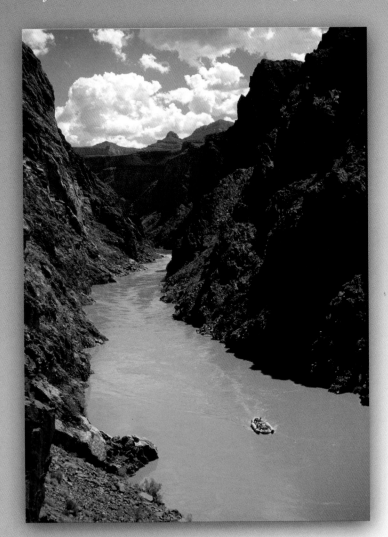

A WITH BINOCULARS, look for the Tonto Trail, just visible above the saddle that connects The Battleship to the South Rim. This trail travels along the Tonto Platform for ninety-five miles (153 km), from below Moran Point to the east to well beyond Havasupai Point to the west.

B SHIVA TEMPLE, elev. 7,570 feet (2,307 m). As seen from the South Rim, Shiva Temple looks as if it is connected to the North Rim. But distances are deceiving—almost two miles (3 km) separate Shiva from the North Rim. The top of Shiva Temple is flat and forested, about 1/3 square mile (86 ha) in size. As with all of the canyon's temples and buttes, Shiva will shrink over time as geologic processes slowly erode its perimeter. Sometime in the future (perhaps hundreds of thousands of years from now), Shiva Temple will look more like today's slender Isis Temple. And, by then, Isis Temple will have eroded down to a low, broad mesa.

C THE RIMROCK OF GRAND CANYON is the Kaibab Formation, a rock unit originally deposited as sediments on the floor of a shallow sea 270 million years ago. The fossil record shows us that a few million years after the Kaibab Formation was laid down, a global catastrophe of an unknown type killed off 90 percent of the planet's plant and animal species. What is known is that much later, 65 million years ago, a large comet or meteor struck Earth, causing or abetting another catastrophic event that killed off the dinosaurs.

Left: The colorful Colorado River wiggles through the Upper Granite Gorge below Grand Canyon Village. O'Neill Butte, near the South Kaibab Trail, stands on the center horizon.

28

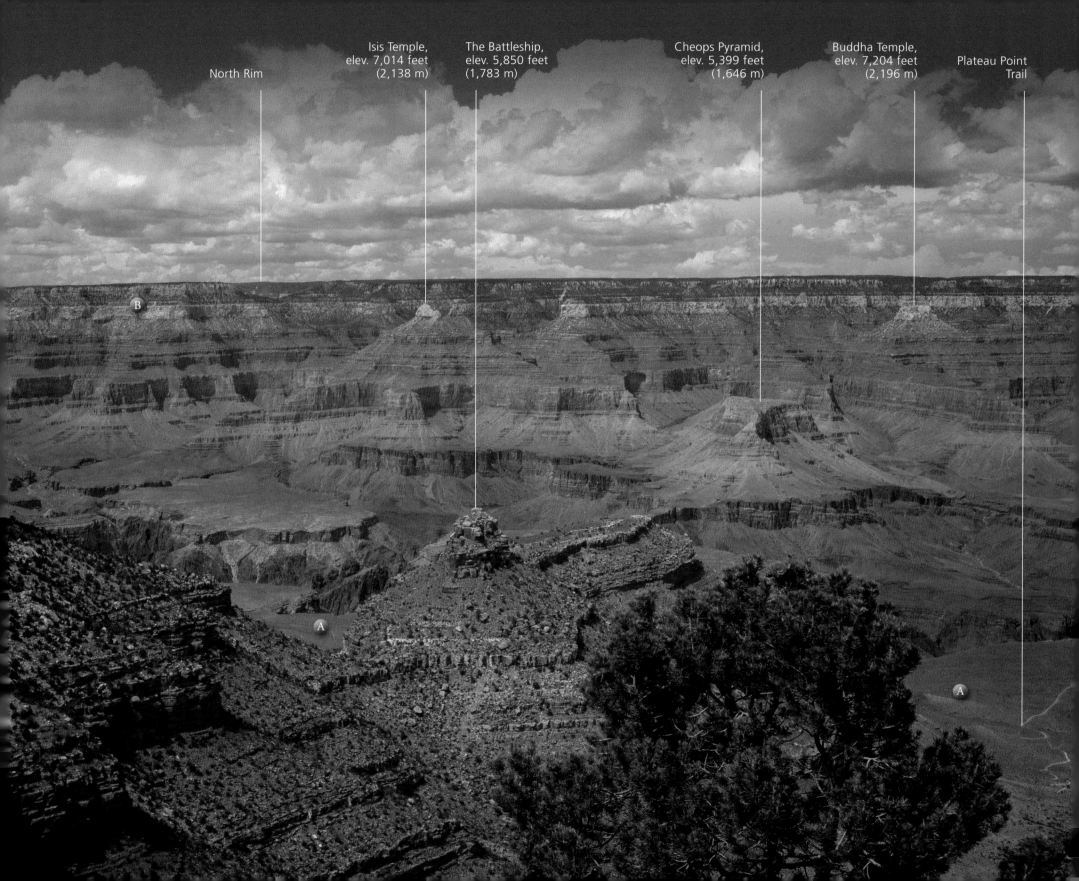

North Rim

Isis Temple,
elev. 7,014 feet
(2,138 m)

The Battleship,
elev. 5,850 feet
(1,783 m)

Cheops Pyramid,
elev. 5,399 feet
(1,646 m)

Buddha Temple,
elev. 7,204 feet
(2,196 m)

Plateau Point
Trail

Yavapai Point ~ 1

Elevation: 7,040 feet (2,146 m). Looking north on an August morning from River Mile 89 to River Mile 86.5

Yavapai Observation Station at Yavapai Point was completed in July 1928 as a geology museum where visitors—by way of both the building's dramatic view of the canyon and its interior exhibits— would be introduced to the canyon's multitude of rock formations and the story of canyon-cutting. Yavapai Observation Station was one of the first educational structures in the National Park System.

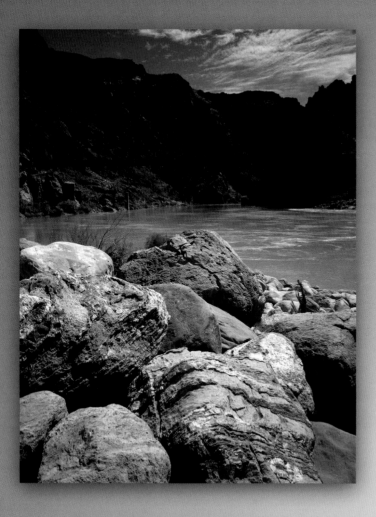

Ⓐ AT THE FOOT of the South Kaibab Trail, the Kaibab Suspension Bridge (known informally as the Black Bridge) can be seen spanning the Colorado River just upstream from the mouth of Bright Angel Creek. The 440-foot (134-m) bridge was built in 1928.

Ⓑ PLATEAU POINT, elev. 3,860 feet (1,177 m). The trail to Plateau Point begins at Indian Garden. It ends where the Tonto Platform does at a more than 1,400-foot (430-m) drop-off to the Colorado River.

Ⓒ PHANTOM RANCH was established as "Rust's Camp" during the improvement of what became the North Kaibab Trail between 1903 and 1907. In 1913, after a visit by former president Theodore Roosevelt, it became known as "Roosevelt Camp." Finally, after the Fred Harvey Company built a central dining hall and several cabins on the site in the early 1920s, it was rechristened Phantom Ranch by architect Mary E. J. Colter. Phantom Ranch can be reached by the North Kaibab, South Kaibab, and Bright Angel trails.

Ⓓ NORTH RIM. In this area of the Grand Canyon, the North Rim is approximately ten miles (16 km) away and lies 1,000 feet (300 m) higher than the South Rim.

Left: The 440-foot (134-m) Kaibab Suspension Bridge over the Colorado River connects the South Kaibab Trail and the River Trail with Phantom Ranch, Bright Angel Campground, and the North Kaibab Trail. The boulders in the foreground were placed there by flash floods and debris flows down Bright Angel Canyon.

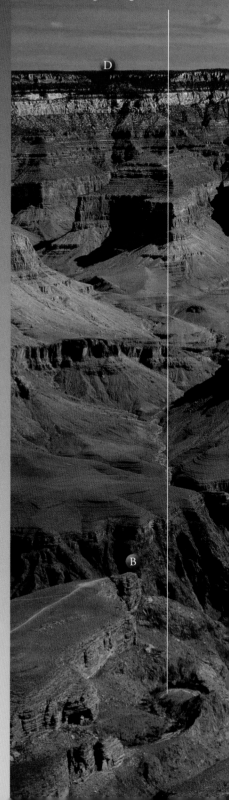

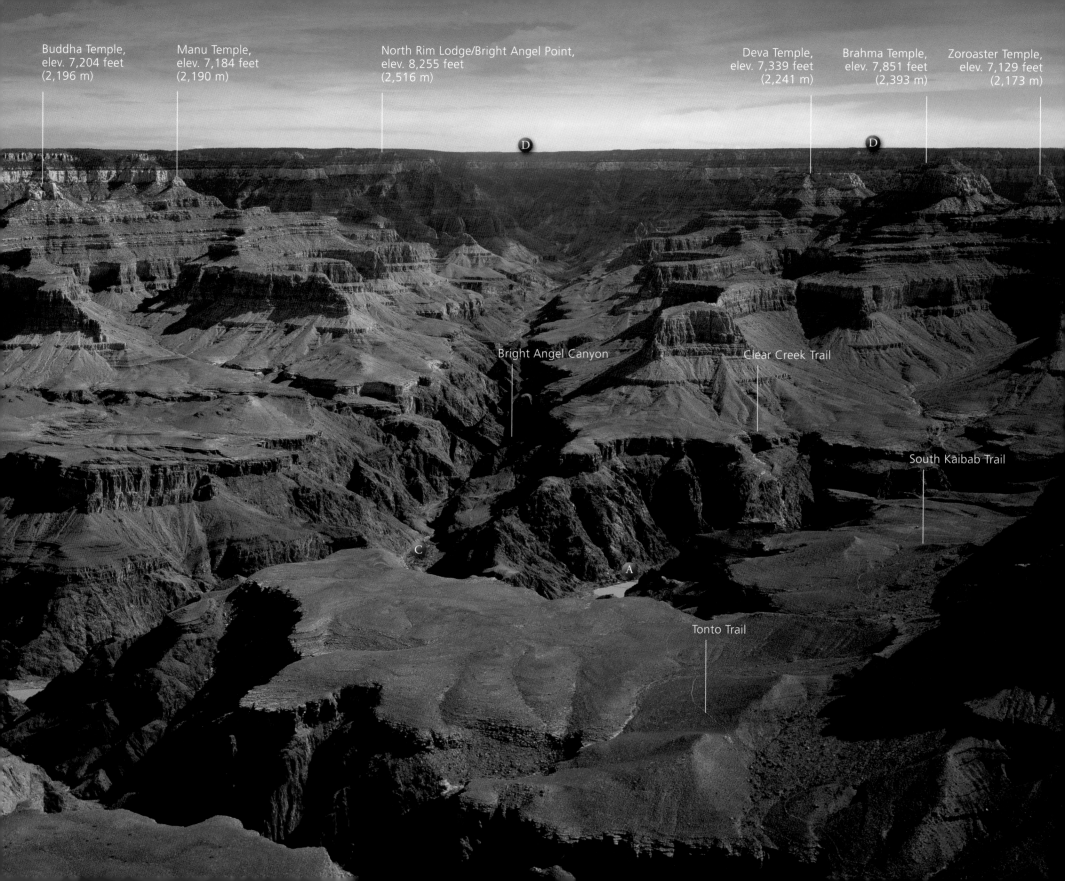

Buddha Temple,
elev. 7,204 feet
(2,196 m)

Manu Temple,
elev. 7,184 feet
(2,190 m)

North Rim Lodge/Bright Angel Point,
elev. 8,255 feet
(2,516 m)

Deva Temple,
elev. 7,339 feet
(2,241 m)

Brahma Temple,
elev. 7,851 feet
(2,393 m)

Zoroaster Temple,
elev. 7,129 feet
(2,173 m)

Bright Angel Canyon

Clear Creek Trail

South Kaibab Trail

Tonto Trail

Yavapai Point ~ II

Elevation: 7,040 feet (2,146 m). Looking northeast at sunset in July from River Mile 85.5 to River Mile 67

The completion of Yavapai Observation Station in 1928 was only one of a number of important Grand Canyon development projects. In the same year the Kaibab Suspension Bridge (visible from Yavapai Point) was built. On the North Rim, the first Grand Canyon Lodge was completed. And near Lees Ferry, Navajo Bridge, which spans Marble Canyon, was finished. The building boom and exuberance of the era, however, was about to end with the crash of the stock market in 1929.

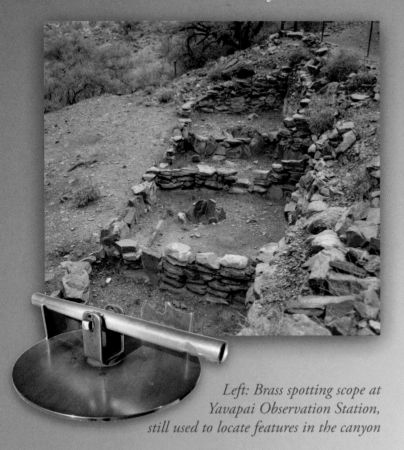

Left: Brass spotting scope at Yavapai Observation Station, still used to locate features in the canyon

Top: Stabilized ancestral Puebloan ruins along the north side of the Colorado River below Yavapai Point

A **DESERT VIEW WATCHTOWER.** With binoculars, look eastward along the rim to see the Desert View Watchtower protruding on the horizon some sixteen miles (26 km) away. The seventy-foot (21-m) tower was completed in 1932 as a focal point of the development at the park's East Entrance.

B **CLEAR CREEK CANYON.** The largest waterfall in Grand Canyon, Cheyava Falls, tumbles into Clear Creek Canyon. However, it flows only in the spring after a winter with a deep North Rim snowpack. Although the waterfall is ten miles (16 km) from Yavapai Point, it can be spotted when conditions allow the falls to flow. The waterfall gushes out of the Redwall Limestone to drop about seven hundred feet (215 m) in a series of cascades.

C **AMPHITHEATERS.** Some of the larger side canyons capture runoff from large, roughly circular areas called "amphitheaters." Such is the case with Clear Creek; its broad upper reaches are called Ottoman Amphitheater. Geologist Clarence Dutton applied the name in 1882.

D **O'NEILL BUTTE,** elev. 6,071 feet (1,850 m). O'Neill Butte is named after William "Buckey" O'Neill, who prospected in the Grand Canyon, promoted the idea of a rail line to the South Rim, and served as sheriff of Yavapai County (in 1889, he captured a group of train robbers near Lees Ferry). Built in the 1890s, his South Rim cabin—the oldest building in its original location in the national park—still stands near Bright Angel Lodge.

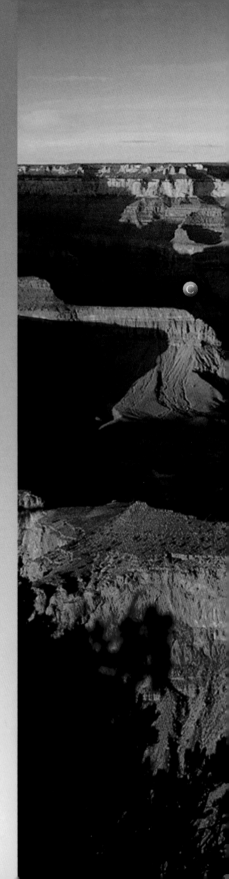

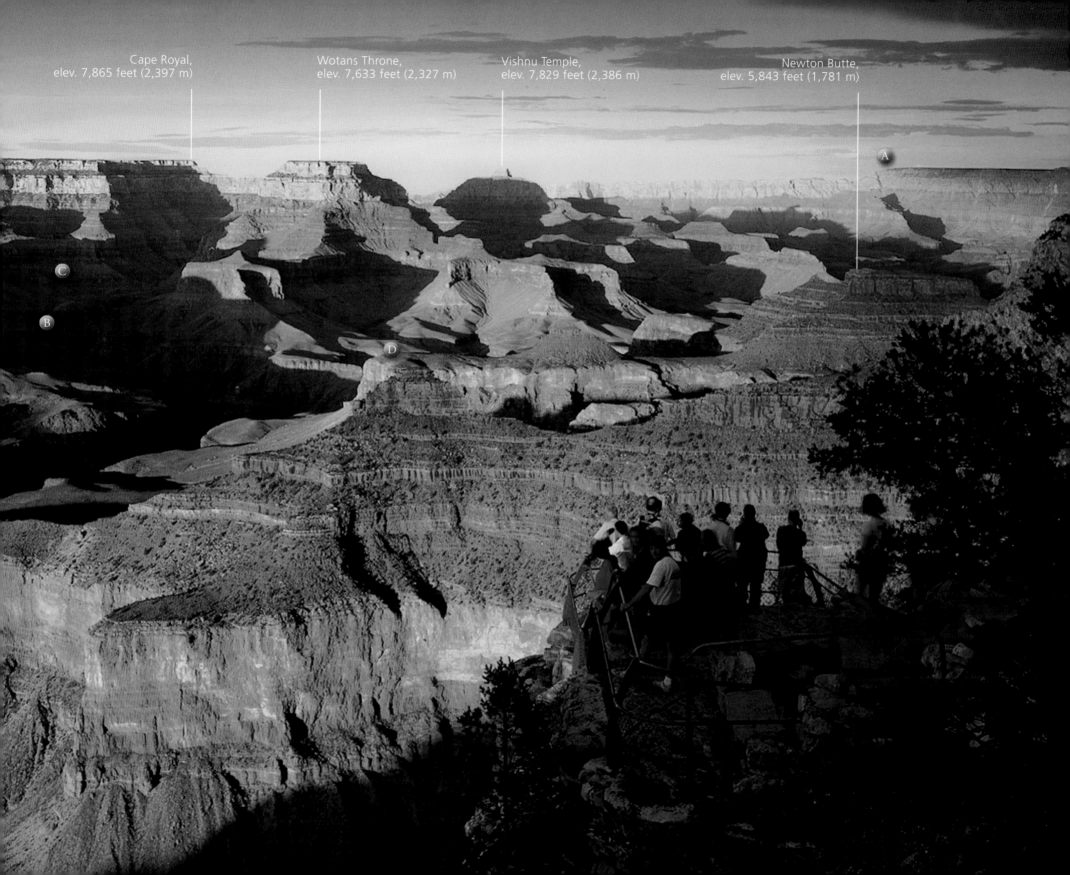

Cape Royal,
elev. 7,865 feet (2,397 m)

Wotans Throne,
elev. 7,633 feet (2,327 m)

Vishnu Temple,
elev. 7,829 feet (2,386 m)

Newton Butte,
elev. 5,843 feet (1,781 m)

A

B

C

D

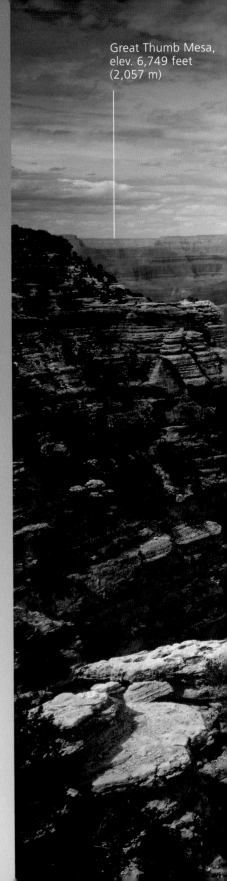

Mather Point ~ 1

Elevation: 7,120 feet (2,170 m). Looking northwest on an early afternoon in September from River Mile 126 to River Mile 88

Located near Canyon View Information Plaza, Mather Point is a major canyon overlook with dramatic views up and down the canyon. It's a great place to go when there's little time to stop at several overlooks.

Above: Prickly pear and hedgehog cacti on the inner canyon's Tonto Platform to the west of the Plateau Point Trail.

Left: Vishnu basement rocks from the Inner Gorge

A THE BRIGHT ANGEL AND PLATEAU POINT TRAILS. The Plateau Point Trail is clearly visible as it leads up to the edge of the inner canyon's Tonto Platform. Less obvious is a portion of the Bright Angel Trail in Garden Creek and Pipe Creek canyons, below and to the right of Plateau Point.

B THE GREAT UNCONFORMITY. Although the rock units of Grand Canyon record an unusually large amount of information about environments that existed here before the canyon was carved, the strata also preserve gaps in the recorded history where rock layers were later eroded away. Such a break in the rock record is called an "unconformity." The Great Unconformity, Grand Canyon's largest, can be found along the interface of the Vishnu Basement Rocks (the dark rocks of the Inner Gorge) and the Tapeats Sandstone (the tan rimrocks of the Inner Gorge). At least 1.2 billion years of geologic records have been lost to lengthy erosional episodes, the last of which ended about 500 million years ago. Although one "location" of the Great Uncomformity is indicated in the photograph, there is no rock layer in place to indicate the missing time. The uncomformity is marked only by the contact point between the Vishnu Basement Rocks and the Tapeats Sandstone.

C TRINITY CANYON. Hundreds of tributary canyons join the main gorge of the Colorado River within the Grand Canyon. Most are dry the majority of the time. A few times a year, rainstorms bring these canyons to life as water courses through them for a few hours. What appears to be a trail along the floor of Trinity Canyon is a dry streambed.

D PHANTOM CANYON. This canyon joins Bright Angel Canyon and lends its name to nearby Phantom Ranch. Unlike most of Grand Canyon's side canyons, Phantom Canyon is home to a perennial stream.

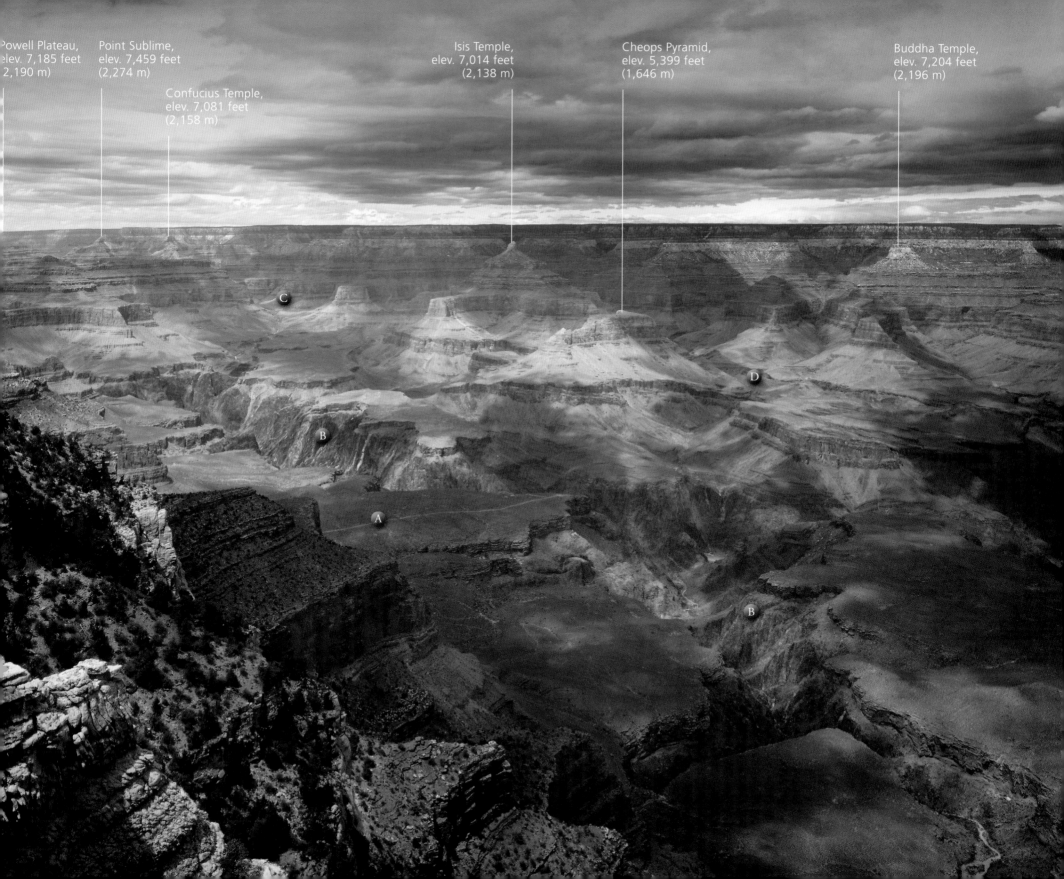

Powell Plateau,
elev. 7,185 feet
(2,190 m)

Point Sublime,
elev. 7,459 feet
(2,274 m)

Confucius Temple,
elev. 7,081 feet
(2,158 m)

Isis Temple,
elev. 7,014 feet
(2,138 m)

Cheops Pyramid,
elev. 5,399 feet
(1,646 m)

Buddha Temple,
elev. 7,204 feet
(2,196 m)

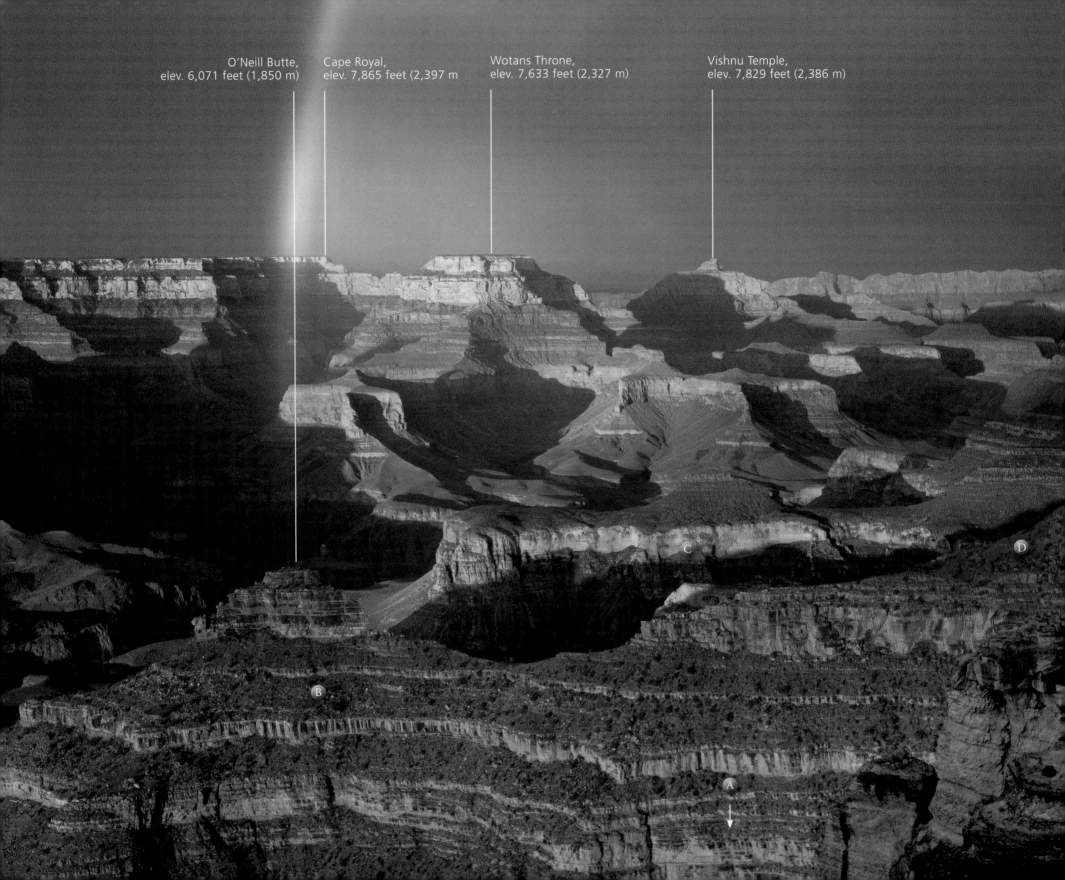

O'Neill Butte,
elev. 6,071 feet (1,850 m)

Cape Royal,
elev. 7,865 feet (2,397 m

Wotans Throne,
elev. 7,633 feet (2,327 m)

Vishnu Temple,
elev. 7,829 feet (2,386 m)

Mather Point ~ II

Elevation: 7,120 feet (2,170 m). Looking northeast on a late afternoon in August from River Mile 85 to River Mile 70.5

In the summer (when the sun is far to the north as sunset approaches) monsoon storms can bring downpours and rainbow displays directly over the canyon. Mather Point was named for Stephen T. Mather, the first director of the National Park Service, serving from 1917 to 1929. His foresight and unwavering dedication to the national park concept still echo through the National Park System today.

A PIPE CREEK DRAINAGE CABIN. Visible with binoculars, the foundation of a small cabin sits along the Pipe Creek drainage on the Tonto Platform, more than 3,300 feet (1,000 m) below Mather Point. The cabin is believed to have been built in the 1920s, when this section of the Tonto Trail was used to travel from the Bright Angel Trail to the 1921 suspension bridge across the Colorado River, before the River Trail was completed.

B SUPAI GROUP. This series of rock layers is 950 feet (290 m) thick in the area below Mather Point. The layers were deposited between 315 and 285 million years ago. Most of the Supai Group is a collection of sandstones, formed from windblown dunes of coastal deserts. Occasional thin limestone beds, which were deposited when the seas encroached upon the dune fields, also comprise the Supai Group. All of this took place long before the Grand Canyon was carved.

C REDWALL LIMESTONE. Water washes down the iron-rich red color of the Supai Group and the overlying Hermit Formation, carrying the crimson sediment downward and staining the underlying Redwall Limestone, which is otherwise gray in color. The Redwall Limestone formed from sediments left by an ocean that existed here 340 million years ago.

D SOUTH KAIBAB TRAIL. The trail runs 6.3 miles (10.1 km) from the rim to the Colorado River. This trail is unusually short, rim to river, and is unusually scenic, because much of it follows the crest of a high ridge. It is also unusually exposed for a Grand Canyon trail, offering no water and almost no shade. Because of this, the South Kaibab Trail is far more dangerous for summer hikers than the Bright Angel Trail.

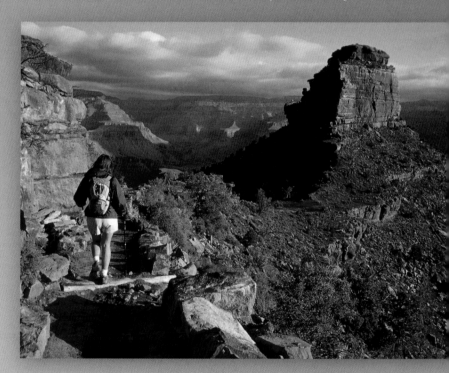

An early morning hiker approaches O'Neill Butte while descending the South Kaibab Trail.

Pioneers and Tourist Development

When John Wesley Powell's river expedition passed through Grand Canyon in 1869, there were no tourists watching for them from the rim above. But the canyon's obscurity was about to end. It was the railroad that carried Major Powell's boats west to the expedition's starting point at Green River, Wyoming, and it was the railroad that would spur tourism to both rims of the Grand Canyon.

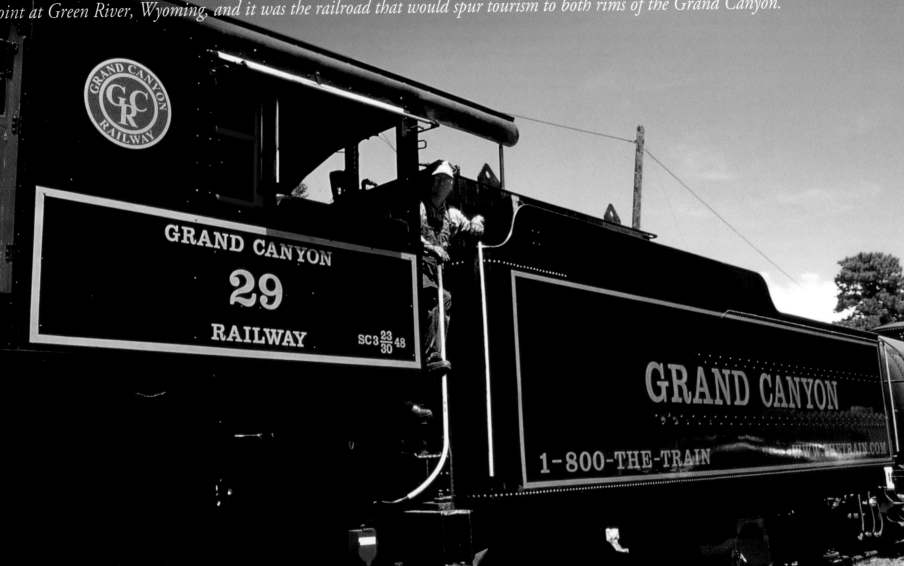

A TRICKLE OF TOURISTS and prospectors began to visit Grand Canyon's South Rim in the 1870s. When the transcontinental railroad came to Flagstaff and Williams, Arizona, in the early 1880s, several tourist camps soon sprang up along the South Rim at today's Grand Canyon Village, at Grandview Point to the east, and at the South Bass Trail to the west. But because it was difficult to get to the South Rim, tourism was limited.

In 1901, however, a rail spur from Williams to the village was completed and tourist business exploded at the rail terminus. As a result, hotels and camps at Grandview Point and at the head of the South Bass Trail began to see a decline in the number of patrons, and the facilities at those sites eventually closed.

Many of today's South Rim historic buildings date back to the early railroad years. The first section of Kolb Studio was built in 1904 (additions were constructed in 1915 and 1925). Both El Tovar Hotel and Hopi House opened in 1905. The Santa Fe Railway depot was completed in 1910 (it's the only rail station in a national park), and Lookout Studio was finished in 1914.

In 1928 development began at the east entrance to the national park. The focal point became the construction of the Desert View Watchtower, completed in 1932.

Because the North Rim was more isolated, tourist development came slowly. The first camp was started at Bright Angel Point in 1917. By 1926 yearly visitation to the North Rim had grown large enough that the National Park Service closed the primitive Bright Angel Point camp and the then-concessioner, the Union Pacific Railroad, started work on the Grand Canyon Lodge. It opened for business in 1928. The original lodge burned to the ground only four years later but was rebuilt by 1937.

Today the National Park Service at Grand Canyon still struggles with development issues. We all want a canyon unspoiled by human tinkering, but most of us also desire roads, trails, drinking water, campgrounds, hotels, restaurants, and other visitor services. The question we must answer is: Where is the line between enough and too much convenience?

Above left: Captain John Wesley Powell's watch, used during his second expedition to the Grand Canyon in 1871

Above right: Drawing room inside historic Kolb Studio

Below: Bellman's cap emblem, ca. 1910, from Cameron's Hotel, a log structure which is now one of the guest cabins of the Bright Angel Lodge

Opposite: The 1906 Locomotive No. 29 is one of four steam engines the modern-day Grand Canyon Railway uses to pull trains to and from the South Rim during the summer.

Yaki Point ~ 1

Elevation: 7,262 feet (2,213 m). Looking northwest on an early afternoon in September from River Mile 92 to River Mile 88

The South Kaibab Trail begins its descent from the rim about a mile south of the overlook and can be seen on the ridge below. Yaki Point was named after the Yaki (or Yaqui) Indians of Mexico.

A FROM YAKI POINT, a long section of the South Kaibab Trail is visible as it passes east of O'Neill Butte and on down to the Colorado River. Farther to the west, the Plateau Point Trail is prominent. A small section of the Bright Angel Trail is less obvious but can be spotted just below the Plateau Point Trail.

B UPPER GRANITE GORGE. The oldest rocks in the Grand Canyon—ranging from 1.7 to 1.84 billion years old—are exposed in three canyon segments known collectively as the Granite Gorge. For river runners floating down the Colorado River, Upper Granite Gorge is the first of these segments they encounter.

C THE GRAND CANYON SUPERGROUP. Between 1,200 million and 740 million years ago, some 12,000 feet (3,650 m) of sedimentary strata were deposited on top of the even older Vishnu basement rocks. Most of the Supergroup rock layers were lost to erosion before the younger Tapeats Sandstone was laid down, although pockets of Supergroup rocks are visible in many areas of the inner canyon.

D PHANTOM CANYON. This canyon hosts a beautiful stream. The lush riparian vegetation along the canyon floor can be seen from Yaki Point. Phantom Ranch lies in Bright Angel Canyon just downstream from the mouth of Phantom Canyon.

Above: Ancient mudcracks in the Dox Formation, one of the rock layers in the Grand Canyon Supergroup

Left: The badge of Chief Park Naturalist Louis Schellbach, who worked at Grand Canyon from the mid-1930s until 1957.

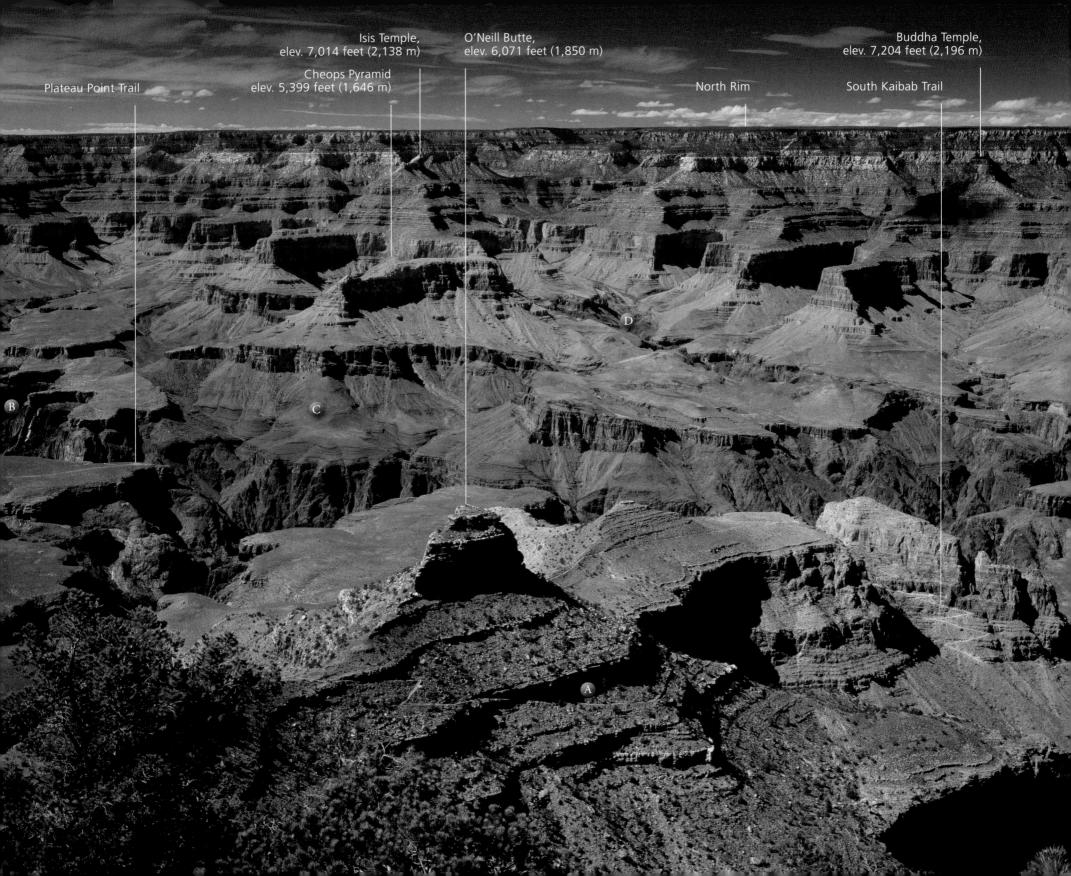

Plateau Point Trail

Cheops Pyramid
elev. 5,399 feet (1,646 m)

Isis Temple,
elev. 7,014 feet (2,138 m)

O'Neill Butte,
elev. 6,071 feet (1,850 m)

North Rim

Buddha Temple,
elev. 7,204 feet (2,196 m)

South Kaibab Trail

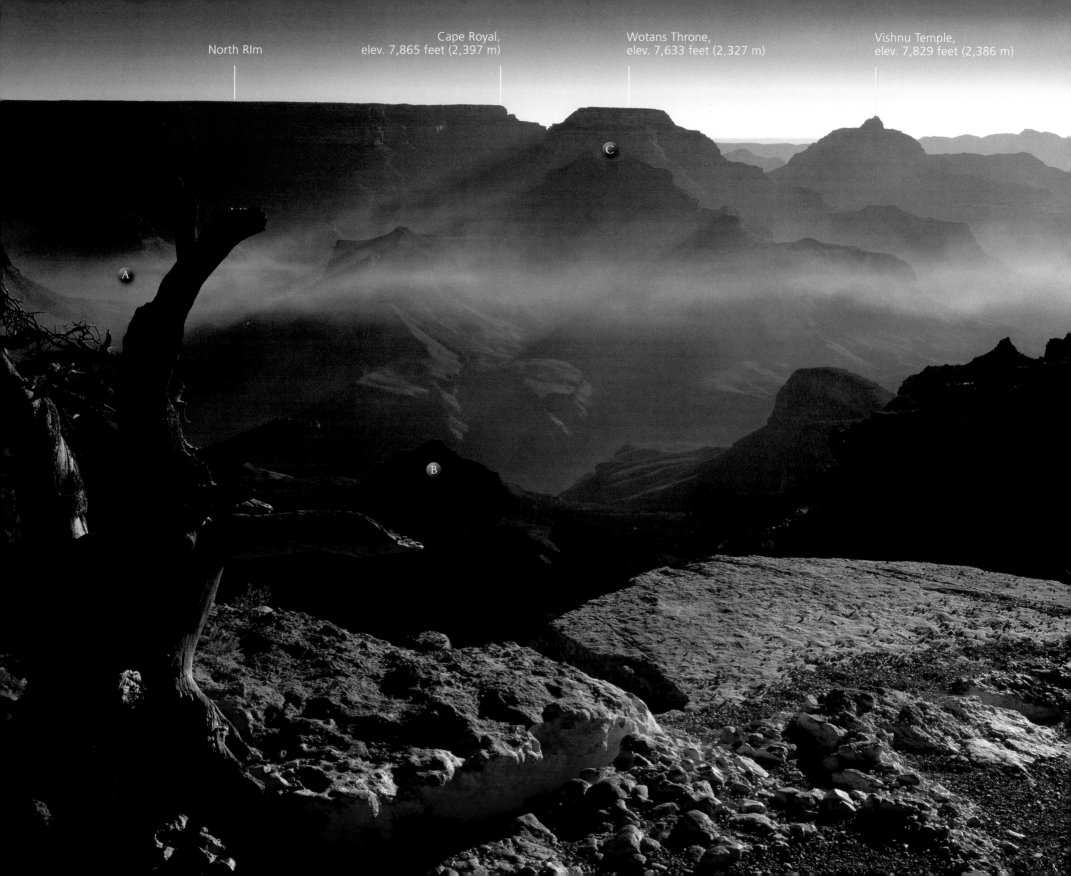

North RIm

Cape Royal,
elev. 7,865 feet (2,397 m)

Wotans Throne,
elev. 7,633 feet (2,327 m)

Vishnu Temple,
elev. 7,829 feet (2,386 m)

Yaki Point ~ II

Elevation: 7,262 feet (2,213 m). Looking northeast on a smoky September morning from River Mile 84.5 to River Mile 75

The Grand Canyon's appearance changes dramatically along its 277-mile length. Its rim and river elevations change, its suite of rock layers varies a little, and its cross section evolves from place to place. Yaki Point offers a great view of the "classic" Grand Canyon, deep and highly dissected, but with distant hints of a shallower Grand Canyon upstream to the east and north, and a canyon dominated by the large inner-canyon Esplanade platform to the west.

Ⓐ CLEAR CREEK CANYON. A vigorous stream of clear water flows to the Colorado through this canyon. River runners often stop at the mouth of the creek to wade up the stream to a refreshing waterfall.

Ⓑ PATTIE BUTTE, elev. 5,315 feet (1,620 m). James Ohio Pattie was a trapper and explorer who may have passed by Grand Canyon in 1826, although his account of the journey, *Personal Narratives* (1831), is considered fundamentally inaccurate by most historians. However, if the book records "embellished" descriptions of Pattie's actual journeys, he may well have been the first American citizen to see the Grand Canyon. He didn't seem to be impressed, however, referring to its temples as "horrid mountains" and the river as "depriving all human beings of the ability to descend to its banks, and make use of its waters."

Ⓒ ANGELS GATE, elev. 6,761 feet (2,061 m). Two pillars of Coconino Sandstone rise from the summit of this temple, creating an airy gateway. Angels Gate should not be confused with Angels Window, a natural arch near Cape Royal.

Inset: Large game trap, ca. 1911, found in the inner canyon

Right: Clear Creek flows clean and cold through Clear Creek Canyon.

Grandview Point ~ 1

Elevation: 7,399 feet (2,255 m). Looking west at sunset in August from River Mile 88.5 to River Mile 80

The Grandview Point (Grand View Point in the nineteenth and early twentieth century) area was the canyon's first important nexus of mining and tourism activities in the late 1800s. In the 1890s, the Grand View Trail (today's Grandview Trail) and the Grand View Hotel were built nearby. The Grand View boom, however, collapsed when the railroad arrived at the rim thirteen miles to the west.

As you descend trails off the South and North rims, the vegetation changes dramatically from ponderosa pines to more drought-tolerant plants, such as this Utah agave photographed on Horseshoe Mesa along the Grandview Trail.

Ⓐ **SOUTH KAIBAB TRAIL.** A small section of the South Kaibab Trail can be seen switchbacking through the Redwall Limestone far to the west.

Ⓑ **THE NORTH RIM.** Because the plateau through which the canyon has cut dips gently to the south, the North Rim is higher than the South Rim. As a result, more precipitation falls on the forests of the North Rim, and the resulting surface and underground water flow toward the canyon rather than away. (On the South Rim, water tends to flow southward, away from the canyon.) The greater runoff from the North Rim has eroded away rock and sediment at a faster rate than in areas below the South Rim. As a result, in this section of the canyon, the North Rim is about twice as far from the Colorado River as is the South Rim. The accelerated erosion of the North Rim has also been responsible for the sculpting of the majority of the canyon's temples and peaks.

Ⓒ **GRAPEVINE CANYON.** Grapevine Canyon joins the Colorado River at Grapevine Rapid, a cataract known for its many large waves. The 1869 Powell Expedition portaged their boats around the rapid. In 1960 one of four jet boats making the one-and-only upstream run of the Colorado in Grand Canyon was lost in Grapevine Rapid. As it sank, the pilot pulled the keys out of the ignition to give back to the owner.

Ⓓ **ABOUT 800 CUBIC MILES** (3,335 km³) of rock have been carted away by the Colorado River to create the Grand Canyon. That figure is impressive, but if it were not for the temples, mesas, towers, ridges, and side canyons that populate the interior of the canyon, the canyon would not be nearly so intricate. It's what hasn't been carted away that makes the canyon grand enough to be listed as one of the seven natural wonders of the world.

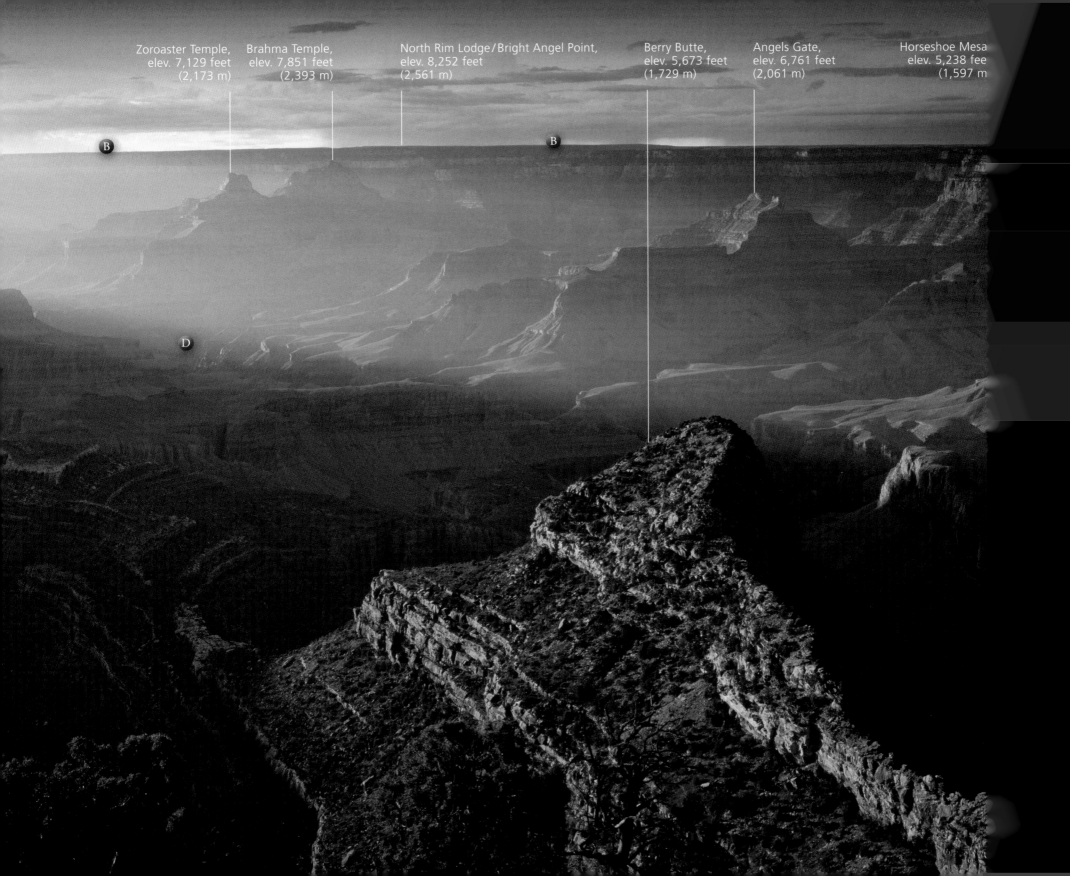

Zoroaster Temple, elev. 7,129 feet (2,173 m)

Brahma Temple, elev. 7,851 feet (2,393 m)

North Rim Lodge/Bright Angel Point, elev. 8,252 feet (2,561 m)

Berry Butte, elev. 5,673 feet (1,729 m)

Angels Gate, elev. 6,761 feet (2,061 m)

Horseshoe Mesa elev. 5,238 fee (1,597 m

Angels Gate,
elev. 6,761 feet
(2,061 m)

Berry Butte,
elev. 6,633 feet
(2,022 m)

Grandview Point ~ II

Elevation: 7,399 feet (2,255 m). Looking north at sunset in August from River Mile 85.5 to River Mile 78

A few months after the railroad arrived at the South Rim, the first automobile made the trek from Flagstaff. It arrived at the Grand View Hotel near what was then called Grand View Point on January 4, 1902, after five days of technical difficulties. The steam-driven machine was the first sign of a flood of automobiles, which, by 1926, had replaced the railroad as the most popular way to get to the canyon.

Inset: Tools of Grand Canyon miners, an oil lamp and tin that once held a safety cord. Both artifacts were found in the inner canyon by NPS rangers.

Ⓐ THE RIM OF THE GRAND CANYON is convoluted. Although the Colorado River's route through the canyon extends an impressive 277 miles (446 km), it has been estimated that the rim length of the canyon exceeds 2,750 miles (4,425 km).

Ⓑ GRANDVIEW TRAIL. Pete Berry constructed the Grandview Trail in 1892 as a route for packing copper ore out of the canyon. It was originally called the Berry Trail and, briefly, the Grand View Trail. Today the trail is categorized by the National Park Service as a "threshold" trail, meaning it is a secondary route, one that is not regularly maintained or patrolled.

Ⓒ UPPER GRANITE GORGE. The Colorado River flows through this steep-walled inner canyon. The elevation of the river in this vicinity is 2,500 feet (760 m), 4,899 feet (1,493 m) below Grandview Point. A number of the canyon's largest rapids are clustered along this stretch of the Inner Gorge.

Ⓓ HANCE CANYON. John Hance arrived at Grand Canyon in 1883 and became the canyon's first Anglo resident. He improved what became known as the Old Hance Trail and, in 1894, built a new trail, the New Hance (Red Canyon) Trail, after his first trail was obliterated by rockslides.

Ⓔ MINING HORSESHOE MESA. Pete Berry, who also built the Grandview Trail and the Grand View Hotel that stood at Grandview Point around the turn-of-the-twentieth century, discovered copper veins on Horseshoe Mesa in the spring of 1890. Berry's strike became known as the Last Chance Mine, and he built an operation extracting copper ore from beneath Horseshoe Mesa and hauling it to the South Rim on muleback. The mine remained in operation until 1907, when copper prices crashed and the huge expense of hauling ore to the rim doomed the Last Chance Mine.

Top left: Ruins of a mining cabin on Horseshoe Mesa along the Grandview Trail.

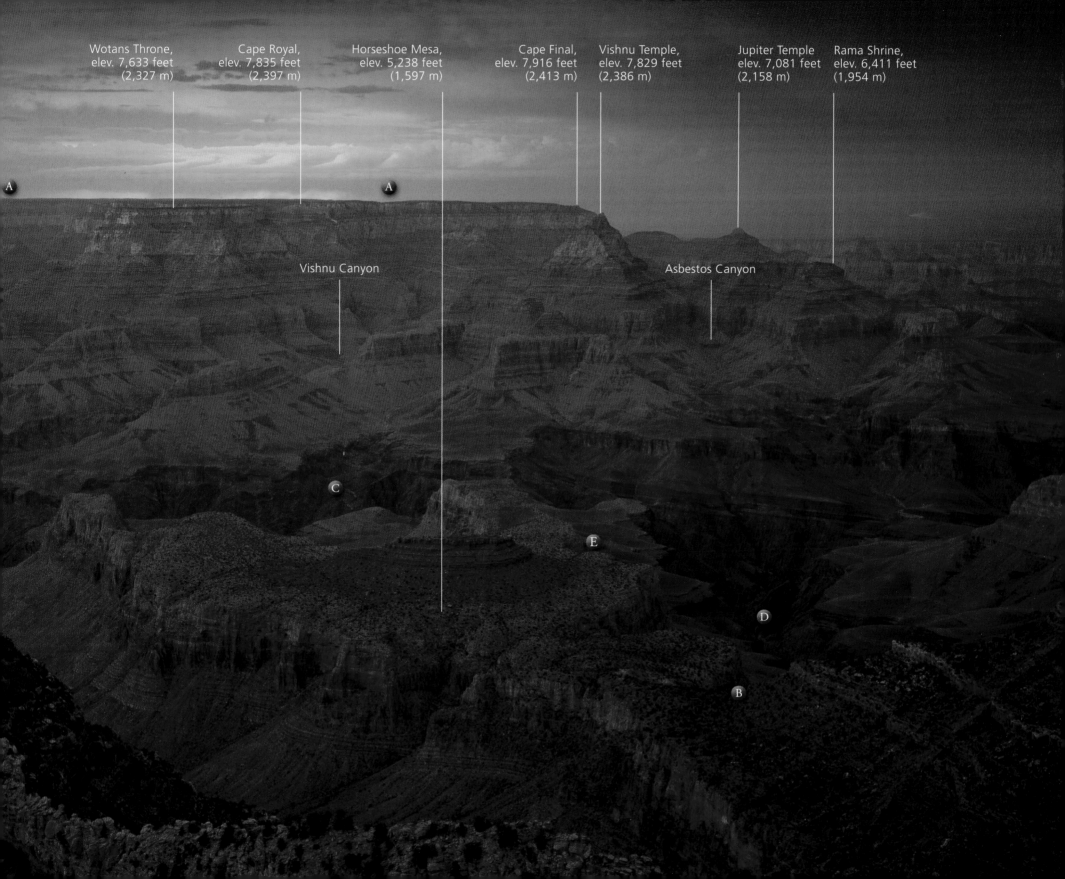

Wotans Throne,
elev. 7,633 feet
(2,327 m)

Cape Royal,
elev. 7,835 feet
(2,397 m)

Horseshoe Mesa,
elev. 5,238 feet
(1,597 m)

Cape Final,
elev. 7,916 feet
(2,413 m)

Vishnu Temple,
elev. 7,829 feet
(2,386 m)

Jupiter Temple
elev. 7,081 feet
(2,158 m)

Rama Shrine,
elev. 6,411 feet
(1,954 m)

A

A

Vishnu Canyon

Asbestos Canyon

C

E

D

B

What Grand Canyon Is Not . . .

1. A CATASTROPHIC "CRACKING OPEN" of the earth did not create the Grand Canyon. It was carved, bit by bit, by the Colorado River.

2. A RIVER AS WIDE as today's canyon did not carve the Grand Canyon. Although the river has at times been significantly larger than it is today (such as when the mountain glaciers rapidly melt at the end of an ice age), the canyon's great width comes from the gradual decay of its walls as they fall toward the rather narrow canyon excavated by the river.

3. IT IS NOT THE DEEPEST canyon on Earth. Copper Canyon in Mexico is a little deeper and there are other canyons that have been cut through mountainous regions that offer ill-defined rims that can with some justification be interpreted as deeper.

4. THE OLDEST ROCKS ever found are not at the Grand Canyon. The rocks at the bottom of the canyon are ancient but nowhere close to the oldest found on Earth.

5. DINOSAUR FOSSILS are not contained in the canyon. Even the youngest rocks at Grand Canyon are older than the earliest dinosaurs.

6. THE CANYON IS NOT VISIBLE in its entirety from any single overlook. Even the most all-encompassing overlooks reveal less than a quarter of the length of the canyon.

7. RATTLESNAKES, scorpions, and tarantulas are not the canyon's major dangers. Although such creatures live in the canyon, just as they do in many other places, the canyon is not crawling with them. It's the canyon's ruggedness and summer heat that loom as its main perils.

8. "THE PRESIDENTS' FACES" are not at the Grand Canyon. (Those are found elsewhere in the National Park System.)

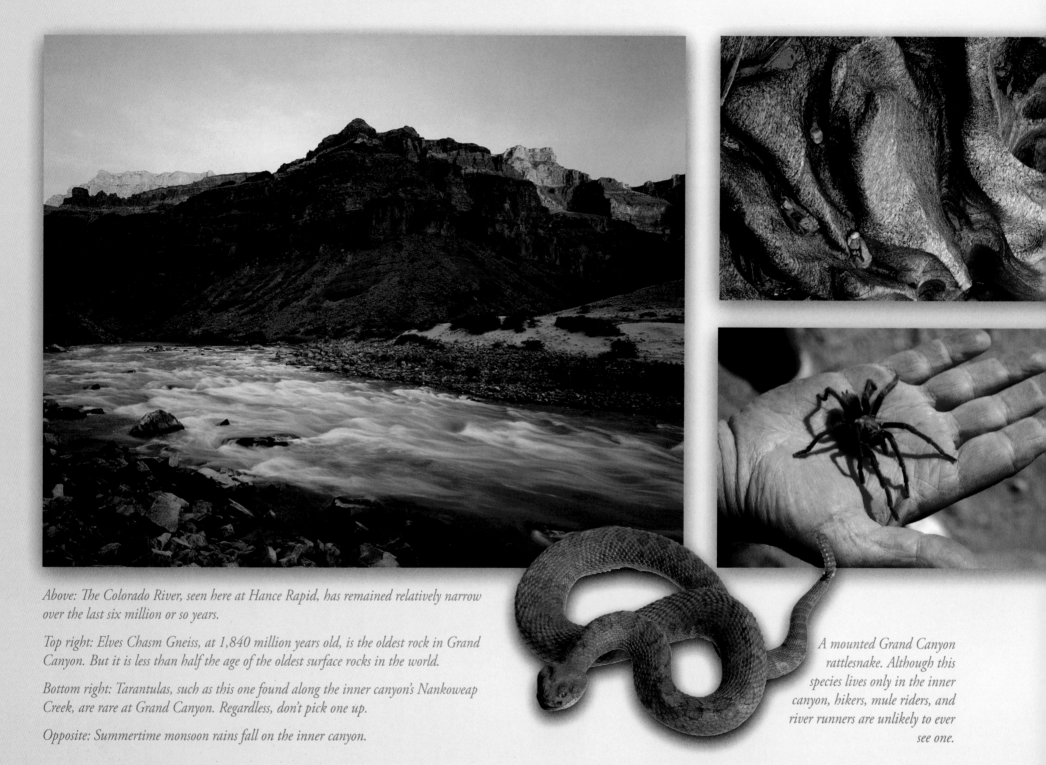

Above: The Colorado River, seen here at Hance Rapid, has remained relatively narrow over the last six million or so years.

Top right: Elves Chasm Gneiss, at 1,840 million years old, is the oldest rock in Grand Canyon. But it is less than half the age of the oldest surface rocks in the world.

Bottom right: Tarantulas, such as this one found along the inner canyon's Nankoweap Creek, are rare at Grand Canyon. Regardless, don't pick one up.

Opposite: Summertime monsoon rains fall on the inner canyon.

A mounted Grand Canyon rattlesnake. Although this species lives only in the inner canyon, hikers, mule riders, and river runners are unlikely to ever see one.

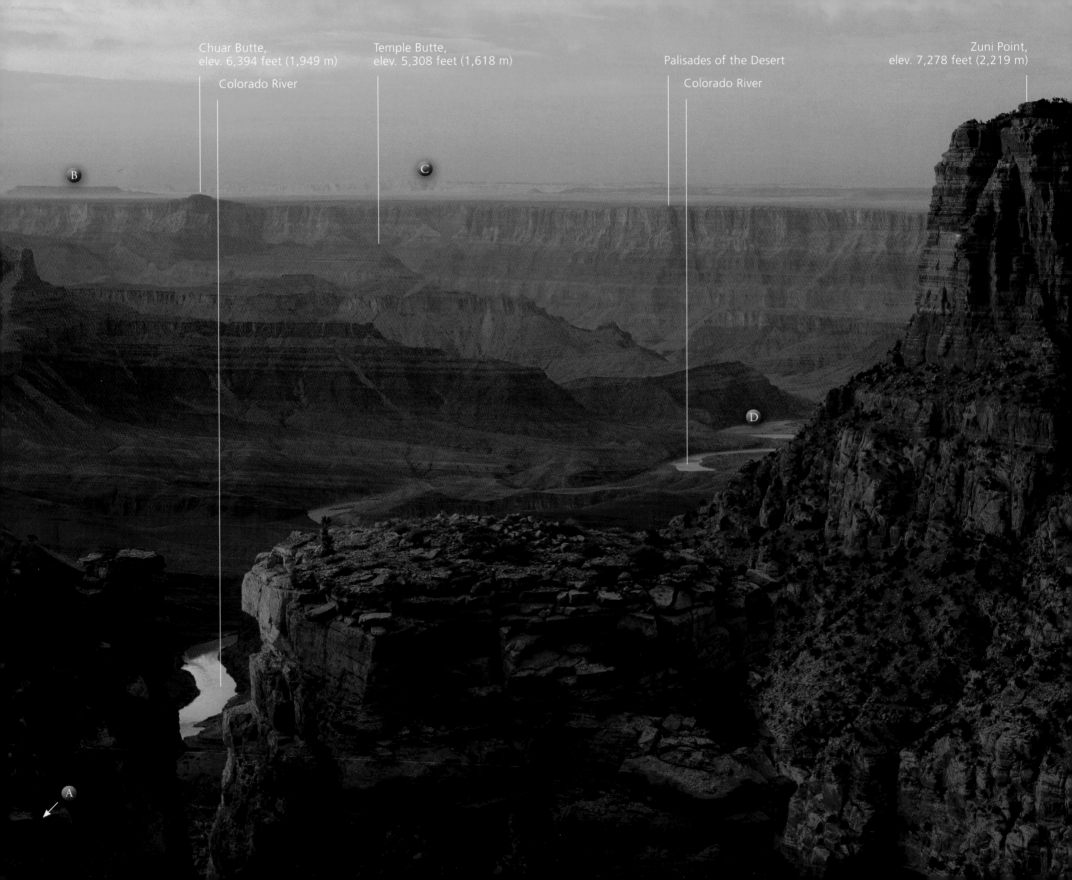

Chuar Butte,
elev. 6,394 feet (1,949 m)

Colorado River

Temple Butte,
elev. 5,308 feet (1,618 m)

Palisades of the Desert

Colorado River

Zuni Point,
elev. 7,278 feet (2,219 m)

Moran Point

Elevation: 7,160 feet (2,182 m). Looking northeast at sunset in July from River Mile 58.5 to River Mile 74.5

Moran Point was named after painter Thomas Moran, whose paintings portrayed the splendor of many of the West's most imposing landscapes. Beginning in 1871 Moran accompanied several U.S. Government Geological Survey teams, including John Wesley Powell's overland survey to the Grand Canyon in 1873. Moran was one of the most effective and venerated artists to convey to the world the grandeur of the Grand Canyon and other natural wonders of the West.

Ⓐ THE NEW HANCE TRAIL travels eight miles (13 km) through Red Canyon from rim to river. The trailhead is well west of the overlook. But below the overlook, a careful observer with binoculars will make out a thin thread of trail heading toward the Colorado River.

Ⓑ SHINUMO ALTAR, elev. 6,519 feet (1,987 m). Shinumo Altar is a remnant of the Moenkopi Formation capped with more-resistant Shinarump Conglomerate, both slightly younger than Grand Canyon's rimrock of the Kaibab Formation. Because the Moenkopi erodes more easily than the Kaibab beneath it, only traces of it have survived in the vicinity of Grand Canyon. Shinumo Altar is thirty-nine miles (63 km) from Moran Point.

Ⓒ THE ECHO CLIFFS developed along the Echo Cliffs Monocline, a fold in the rock where one side of the disturbance is pushed higher than the other. The Colorado River crosses the monocline at Lees Ferry, where Glen Canyon abruptly ends and Grand Canyon suddenly begins because the monocline lifts Grand Canyon rock layers to the surface for the first time.

Ⓓ TANNER RAPID. The rapid boasts a drop of twenty feet (6 m), but it is not considered difficult by river runners. In addition to the rapid, several Grand Canyon features—a trail, a canyon, and a mine— are named after Seth Tanner, a Mormon settler who prospected and traded in and around eastern Grand Canyon in the late 1800s. He improved an old American Indian route to the river that became known as the Tanner Trail.

The New Hance Trail through Red Canyon reaches the Colorado River at Hance Rapid. The trail begins about a mile southwest of Moran Point.

Lipan Point

Elevation 7,360 feet (2,243 m). Looking north on a June morning from River Mile 73 to River Mile 70.5

Lipan Point was originally named Lincoln Point after President Abraham Lincoln. It was renamed in 1902 by cartographer François Emile Matthes to join a series of South Rim overlooks named in honor of American Indian tribes. The Lipan Indians of Texas are members of the Apache Indian Nations.

Visible from Lipan Point, remote Unkar Delta on the north side of the Colorado River is home to extensive ruins left by the ancestral Puebloan people, who farmed such crops as corn and squash in the area more than 800 years ago.

Ⓐ Unkar Creek Rapid drops twenty-five feet (7.6 m). If river runners stray too far to the left in the rapid, the ride is guaranteed to be hair-raisingly violent, sometimes more violent than boatmen (both male and female river runners are known as "boatmen") and their boats can handle with grace, aplomb, style, and poise. In other words, they capsize. Look for boats running "dreaded" Unkar Creek Rapid.

Ⓑ Hilltop Ruin. The ancestral Puebloans built this fort-like structure sometime between AD 850 and 1200. Hilltop Ruin became the first archaeological site to be photographed in Grand Canyon when Robert Brewster Stanton did so in 1890 on a river trip while surveying for a proposed river-level railroad through the Grand Canyon. (Fortunately, the rail line was never built.)

Ⓒ This section of Grand Canyon possesses an unusually broad profile where no narrow, vertical-walled gorge hems in the Colorado River. The open, rolling topography can be attributed to the soft, easily eroded Dox Sandstone outcrops that form the riverbanks. (The billion-year-old Dox is part of the Grand Canyon Supergroup.) The Dox Sandstone landscape, much of it cliff-less and wide open, grants rim visitors unusually fine views of long ribbons of the Colorado River. In summer, it also allows the sun to pour down on the river corridor unobstructed; river runners refer to the barren slopes north of this section of the Colorado as Furnace Flats.

Ⓓ Cardenas Lavas. Almost a thousand feet (300 m) of dark volcanic rocks rest on the red Dox Sandstone. At least thirteen different lava flows have been identified, some of them erupting into shallow waters about a billion years ago.

Ⓔ Tapeats Sandstone. This coarse-grained sandstone was laid down in the shallow waters of a sea encroaching from the west 525 million years ago. This was just after an "explosion of life" occurred, as witnessed in the fossil record. Life had begun to proliferate and diversify as never before in four billion years of Earth's history. The sequence of rocks lying above the Tapeats documents an occasionally uninterrupted but geologically rapid march toward ever more sophisticated forms of life.

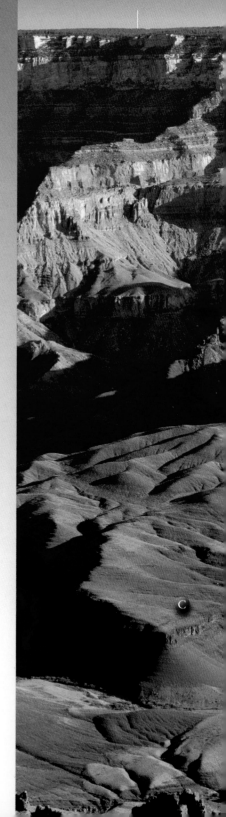

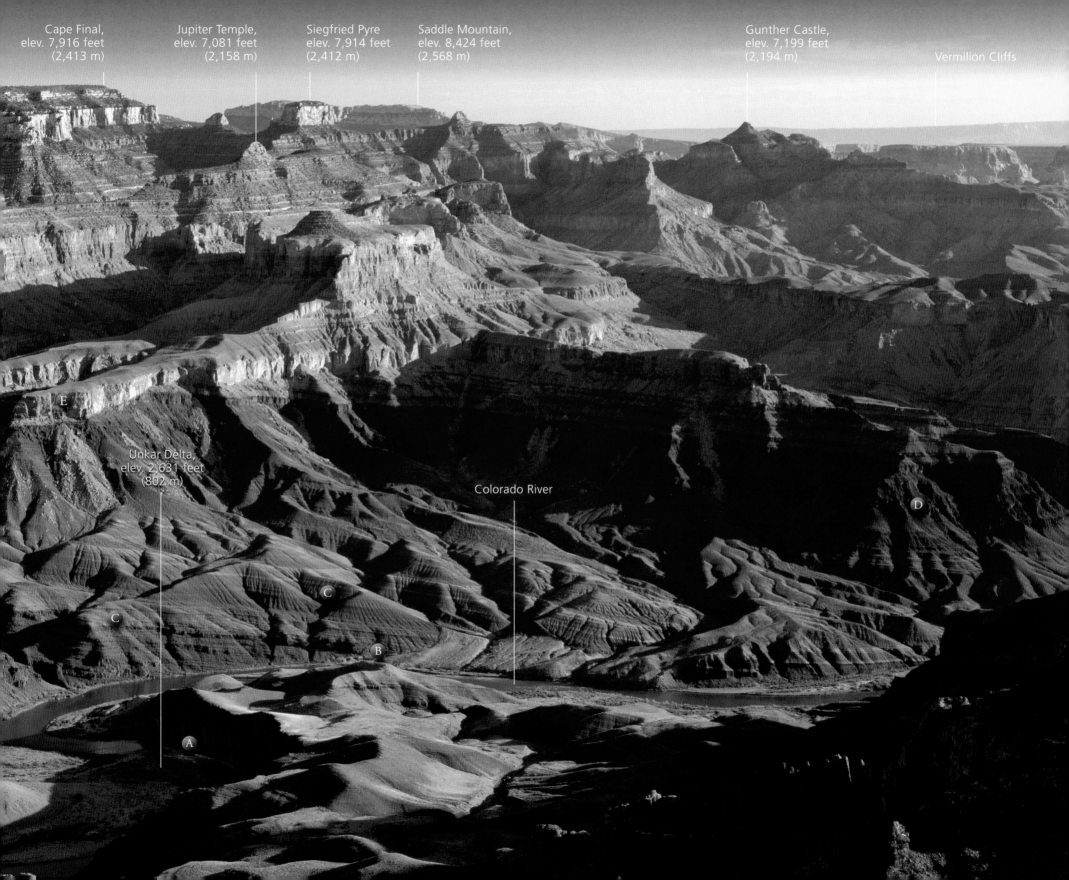

Cape Final,
elev. 7,916 feet
(2,413 m)

Jupiter Temple,
elev. 7,081 feet
(2,158 m)

Siegfried Pyre
elev. 7,914 feet
(2,412 m)

Saddle Mountain,
elev. 8,424 feet
(2,568 m)

Gunther Castle,
elev. 7,199 feet
(2,194 m)

Vermilion Cliffs

Unkar Delta,
elev. 2,631 feet
(802 m)

Colorado River

The Colorado River

The Colorado River's headwaters lie in the Rocky Mountains along the continental divide in Colorado and Wyoming. Although it is the fifth-longest river in the United States at 1,450 miles (2,335 km), its volume is rather modest because its lower half drains the Southwest's desert country.

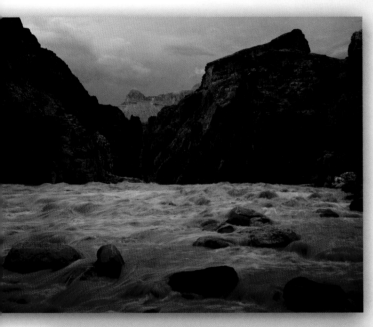

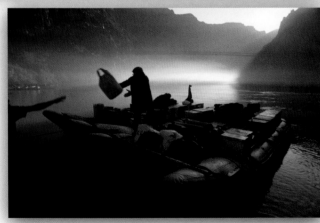

STILL, IT IS THE DESERT PORTION that is responsible for most of the river's fame—it is here that, using the water gathered from the mountains, it has carved a series of extraordinary canyons. Grand Canyon is the most spectacular.

The Colorado River in Grand Canyon is known for its furious rapids. Over the length of the canyon, the river drops 1,900 feet (580 m). There are dozens of respectable rapids along the way and a few that are awesome with falls of ten, twenty, even thirty feet over a relatively short distance. Rapids usually form at the mouths of side canyons where boulders from flash floods and debris flows have been swept into the Colorado. It is here that the channel narrows, the descent steepens, and the river races through, throwing spume into the air.

River runners both love and fear the white-water stretches. The rapids offer a wet rollercoaster ride, but they also demand respect. Like just about everything else at the bottom of the canyon, the Colorado River offers a rigorous test of human resourcefulness. Improved techniques and equipment developed over the past fifty years, however, have made river running ever more safe and enjoyable.

The Colorado River in Grand Canyon is also surprisingly cold, even in summer. When Lake Powell, the reservoir just upstream from Grand Canyon, is near full capacity, the flow of the Colorado River comes from far below the surface where it is little affected by the air temperature. When it enters Grand Canyon at Lees Ferry, the Colorado River is chilly at 47 degrees Fahrenheit (8°C). In the heat of summer it warms about one degree for every thirty miles (48 km) it travels through the canyon. By the time it reaches Phantom Ranch, the water temperature is about 50 degrees (10°C).

In Grand Canyon, the effects of Glen Canyon Dam have been contentious. River runners may use the cold water for shiver-inducing water fights and as a refrigerator for beer and soda, but the dam-controlled flows have inflicted dramatic change along the river corridor. The tamed river allows riparian vegetation to conquer the once-barren shorelines while the once-ubiquitous beaches have largely disappeared for lack of river-flood replenishment. The tangle of vegetation that has flourished along the river has allowed some animal species to prosper unnaturally (including endangered species such as the willow flycatcher), but the cold and often clear water of the river has extirpated or threatened unique native fish.

Despite the environmental problems, the Colorado River in Grand Canyon is still mind-bogglingly scenic and ostensibly unrestrained.

Depending upon the section of canyon floated, the season of the year, and the type of trip (commercial, noncommercial, oar-powered, motorized), most Grand Canyon river trips run anywhere from three to twenty-one days. For most people, Grand Canyon river trips are wild, wonderful adventures; for some people they can become life-changing events. So, be advised, if you choose to join

a Grand Canyon river expedition, these things could happen to you: You might decide your life's trajectory is simply unacceptable. It may become all too obvious that you really should become a river guide, a poet, a National Geographic photographer, a geologist, or a bum.

Life on the river is unique. New rules of behavior must be accepted and old ones jettisoned. Safety on the boats is paramount. In hot weather you must drink even when you are not particularly thirsty. Shade is heaven. Toilet etiquette is entirely novel.

The excitement of rapid-running alternates with the tranquility of hikes into side canyon oases—Elves Chasm, Matkatamiba Canyon, North Canyon, Deer Creek, Saddle Canyon, Havasu Canyon. Who would believe that there could be such glorious sanctuaries tucked into the sunbaked interior of the Grand Canyon?

At night the sounds of the river, gurgling at one camp, rumbling at another camp, lull you to sleep. The stars wheel overhead in a field of midnight blue, their arcs intercepted by the silhouettes of age-old cliffs. It is likely you have never seen so many stars in the heavens. Nor, perhaps, have you heard such melodies in the many songs of flowing water.

On the river, you are more aware of the sky, the clouds, the wind, the shade, the heat, the cold, the sand, the river, the rocks, than you've ever been before. There is the metallic taste of fear at the entrance to an angry rapid and the sweet flavor of relief in the tail waves below. On the river, the canyon is everything, the outer world is nothing, and your former life seems to count for little. No one much cares if you are a millionaire CEO in the upper world. Or on parole. Or both.

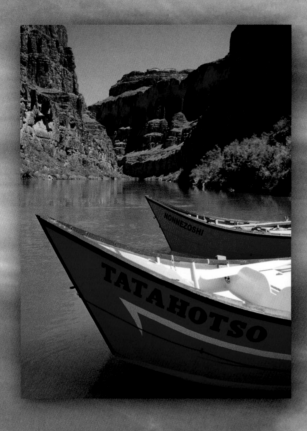

Far more important are your boat-bailing skills. Can you handle the reality that credit cards and cash have little value along the river? Are you willing to help in the galley, load and unload gear, hold on tight in the rapids, drink enough water in the heat of the inner canyon, scramble across boulders, walk along ledges, fully accept dangers, and appreciate the wonders of the river world?

For many, life on the river is addictive with its practical rules that cope with an extreme environment. For those who come to love it, even a dozen trips on Grand Canyon's Colorado River are insufficient. They'll be back again.

Opposite top: The Colorado River's Granite Rapid drops eighteen feet (5.5 m) and is rated as high as 8 on Grand Canyon's 10-point rapid-rating system (with 10 being the most difficult).

Opposite bottom: River runners load gear near the mouth of Bright Angel Creek; the Kaibab Bridge spans the Colorado in the background.

Left: Some river-running companies and private trips use traditional dories instead of rafts to run the Colorado River.

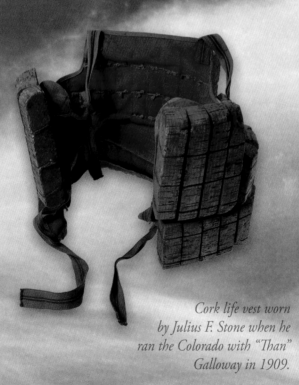

Cork life vest worn by Julius F. Stone when he ran the Colorado with "Than" Galloway in 1909.

Desert View ~ I

Elevation: 7,438 feet (2,267 m). Looking west on a late afternoon in August from River Mile 114 to River Mile 74

Serious development of Desert View as the eastern gateway to the South Rim began in 1928. The seventy-foot-high Watchtower, designed by noted architect Mary Colter, was completed in 1932. The Watchtower and its dramatic viewpoint stand as witnesses to a momentous redirection of the Colorado River, which suddenly abandons its southerly flow to swerve west into the heart of the Grand Canyon.

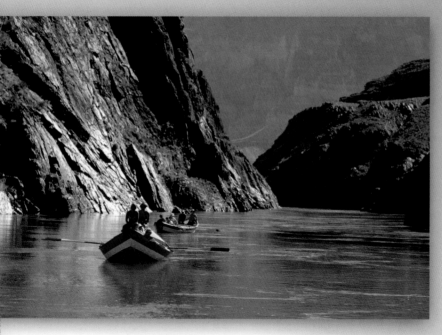

Dories make their way through the Upper Granite Gorge of the Colorado River. Most peolple think of rafts when they ponder Grand Canyon river running, but some make the trip in dories. Dories were originally fishing boats but have been modified to handle both the smooth water between rapids and the violent upheaval of Grand Canyon's mightiest cataracts.

A THE TANNER TRAIL can be spotted running along the top of the Redwall Limestone cliff below Escalante Butte and (farther northeast) Cardenas Butte. This ten-mile (16-km) trail begins near Lipan Point and reaches the Colorado River at Tanner Canyon Rapid.

B UPPER GRANITE GORGE. Downstream from the foot of Hance Rapid, the Colorado River enters Upper Granite Gorge, a forty-mile (65-km) stretch of river inhabited by some of the largest, angriest rapids in the Grand Canyon.

C A CAREFUL OBSERVER will notice that almost all of the canyon's biggest temples lie north of the Colorado River. The reason is simple: The plateau through which the canyon is cut tilts gently to the south, directing surface water and underground water toward the North Rim and into the canyon; but away from the South Rim. As a result, the North Rim's tributaries are cut deeper and the ridges between them have been carved into many more towers, peaks, and temples.

D WOTANS THRONE. Ancestral Puebloan ruins have been found on the summit of this island in the sky even though it is very difficult and dangerous to reach. The character of the structures on this isolated plateau tells archaeologists that in the mid-twelfth century, life had grown difficult for the ancestral Puebloans. The weather was turning cooler and drier, and it may be that the resulting human migrations spawned greater competition for land and resources. The ancestral Puebloans had adopted increasingly defensive strategies, which may explain the presence of ruins on the summit of Wotans Throne.

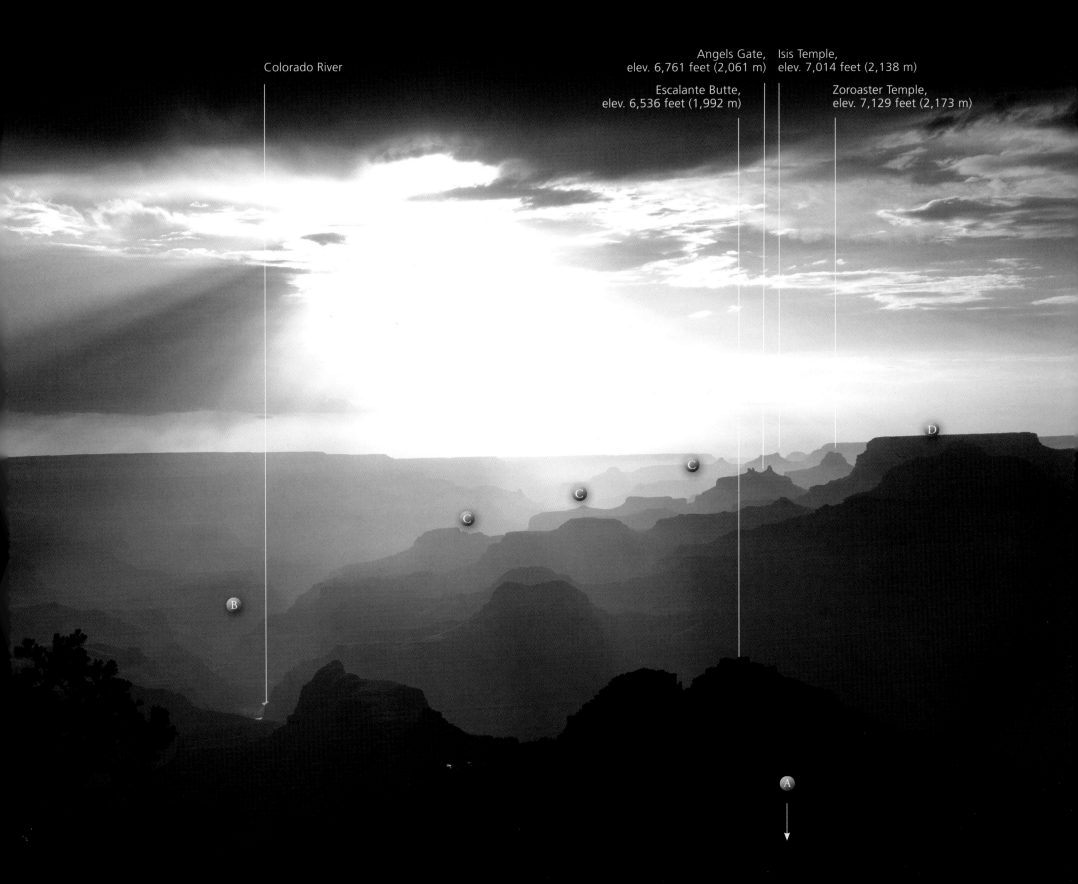

Colorado River

Angels Gate,
elev. 6,761 feet (2,061 m)

Isis Temple,
elev. 7,014 feet (2,138 m)

Escalante Butte,
elev. 6,536 feet (1,992 m)

Zoroaster Temple,
elev. 7,129 feet (2,173 m)

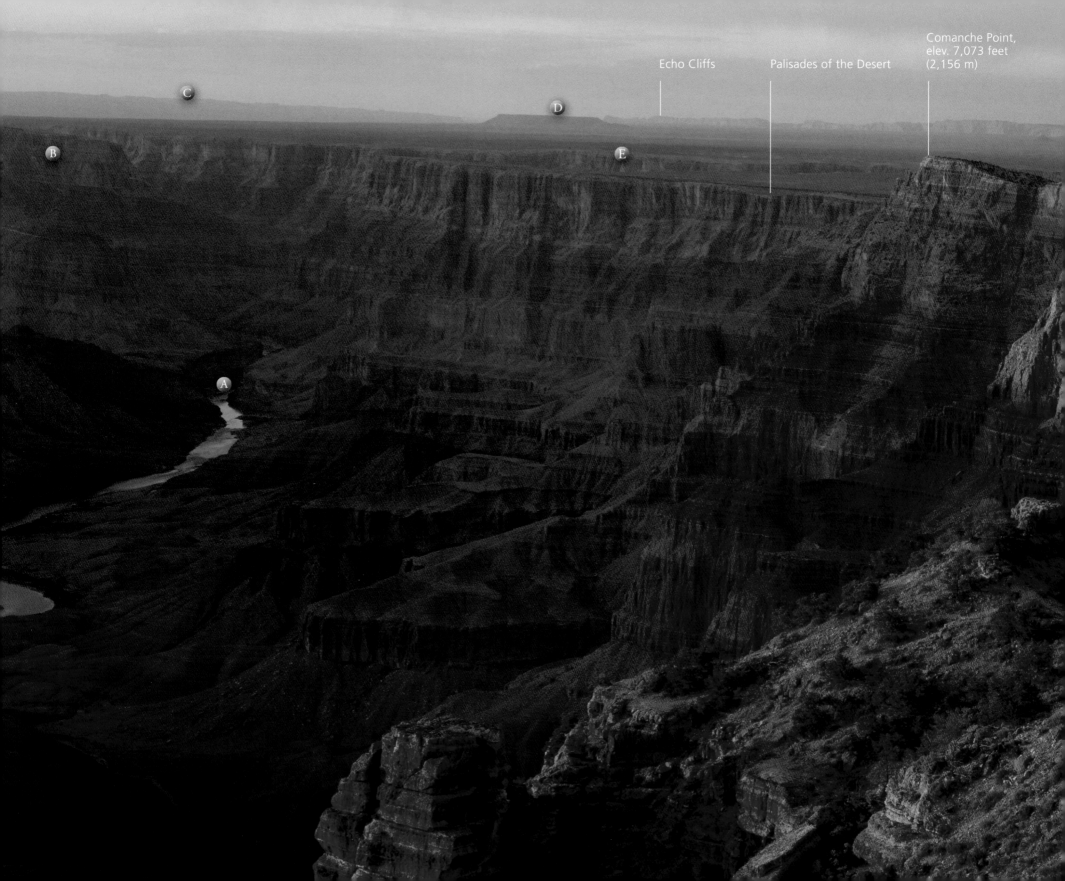

Echo Cliffs

Palisades of the Desert

Comanche Point,
elev. 7,073 feet
(2,156 m)

Desert View ~ II

Elevation: 7,438 feet (2,267 m). Looking north at sunset in August from River Mile 68 to River Mile 59

The name "Desert View" stems from the overlook's unique panorama of the multicolored desert terrains to the northeast and east. Grand Canyon forms the western edge of this "painted desert," the homeland of the Navajo and Hopi tribes.

Ⓐ In the summertime, it is often possible to spot boats parked at Lava Canyon (Chuar) Rapid. The rapid is a popular campsite and lunch spot.

Ⓑ Chuar Butte, elev. 6,394 feet (1,949 m). In 1956 two commercial airliners collided at 21,000 feet (6,400 m) over eastern Grand Canyon. All 128 people aboard the two planes perished in what was then the worst commercial air disaster in U.S. history. One of the planes, a United DC-7, crashed into Chuar Butte, scattering debris down its side. The other airplane, a TWA Super Constellation, crashed at the base of nearby Temple Butte. The catastrophe spurred Congress to form the Federal Aviation Administration.

Ⓒ Paria Plateau. Lees Ferry, at the head of Grand Canyon, lies just to the right and slightly farther away than the southern edge of the plateau. The Paria Plateau became part of Vermilion Cliffs National Monument in 1999.

Ⓓ Shinumo Altar, 6,519 feet (1,987 m). Shinumo is the Paiute name for the ancestral Pueblo, or Anasazi. Frederick S. Dellenbaugh, a member of John Wesley Powell's second river expedition, named Shinumo Altar in 1872 while surveying nearby.

Ⓔ Little Colorado River Gorge. This major tributary of the Colorado River drains eastern Arizona's White Mountains. When in flood stage, the river runs rich with mud. But much of the year, when the upper canyon is otherwise dry, only turquoise spring waters merge with the Colorado at the confluence of the two rivers. The Little Colorado River Gorge is visible to the northeast of Desert View.

Ⓕ The Navajo Nation lies east of Grand Canyon, from Desert View north into southeastern Utah. The Navajo Indian Reservation is the largest in the United States.

Top right: The turquoise waters of the Little Colorado River blend with the green waters of the Colorado at the confluence of the two rivers.

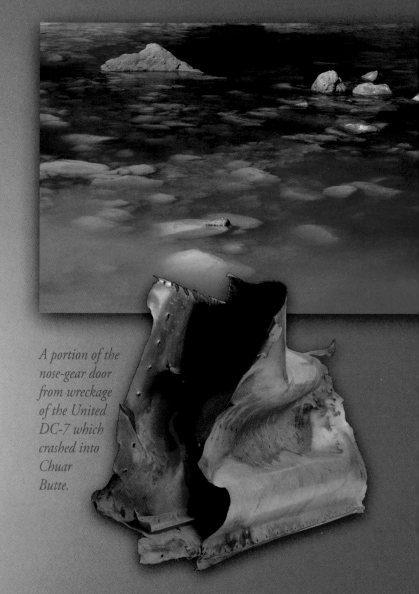

A portion of the nose-gear door from wreckage of the United DC-7 which crashed into Chuar Butte.

PART TWO ~ T

HE NORTH RIM

Lees Ferry

Elevation: 3,116 feet (950 m). Looking downstream from the east bank on a July sunrise from River Mile 1.5

The Colorado River punches through the Echo Cliffs Monocline at and just upstream of Lees Ferry. Glen Canyon and its group of soft sandstones and shales abruptly come to an end, and Grand Canyon, with its older, erosion-resistant series of rocks, comes to river level.

Summer mornings often find the Lees Ferry launch ramp crowded with boaters preparing to begin Grand Canyon river trips. Lees Ferry is considered Mile 0 by Grand Canyon river runners. Most who run the full river in Grand Canyon emerge at Mile 226.

A KAIBAB FORMATION. This rock unit, 270 million years old, forms the rim of the Grand Canyon. At Lees Ferry, it lies at the same elevation as the Colorado River. But as the river runs downhill, cutting down into the Kaibab Limestone and the rock layers that lie beneath it, the Kaibab rises higher and higher above the river. Fifty-three miles (85 km) downstream from Lees Ferry, the Kaibab Limestone tops out on the rim at an elevation of 8,819 feet (2,688 m), more than 6,000 feet (1,830 m) above river level.

B IN GRAND CANYON the Colorado River drops about eight feet per mile (1.5 m/km). By the time it reaches Lake Mead at the western end of the canyon 277 miles (446 km) downriver, the Colorado has lost 1,900 feet (580 m) in elevation. By comparison, the Mississippi River drops only 1,475 feet (450 m) over its entire 2,320-mile length from northern Minnesota to the Gulf of Mexico, descending at a rate of less than a foot per mile.

C THE PARIA PLATEAU and the Paria River are the primary features of Vermilion Cliffs National Monument. In 1996, California condors were first reintroduced in northern Arizona at the Vermilion Cliffs. Scientists selected this release location because condors historically lived in the region, and because the land is still rugged and isolated today. The reintroduction project has been successful—several dozen condors now inhabit the Grand Canyon region. The best places to spot them are at Navajo Bridge and along the South Rim at Grand Canyon Village.

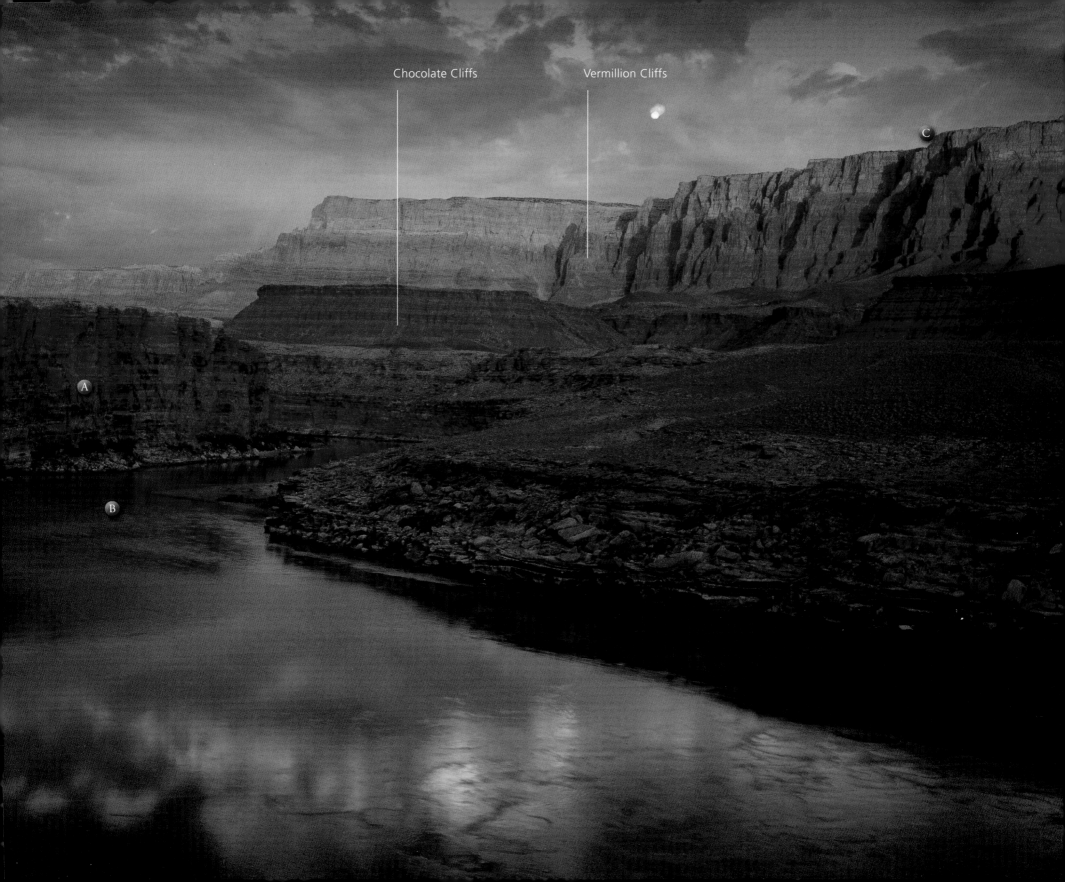

Chocolate Cliffs

Vermillion Cliffs

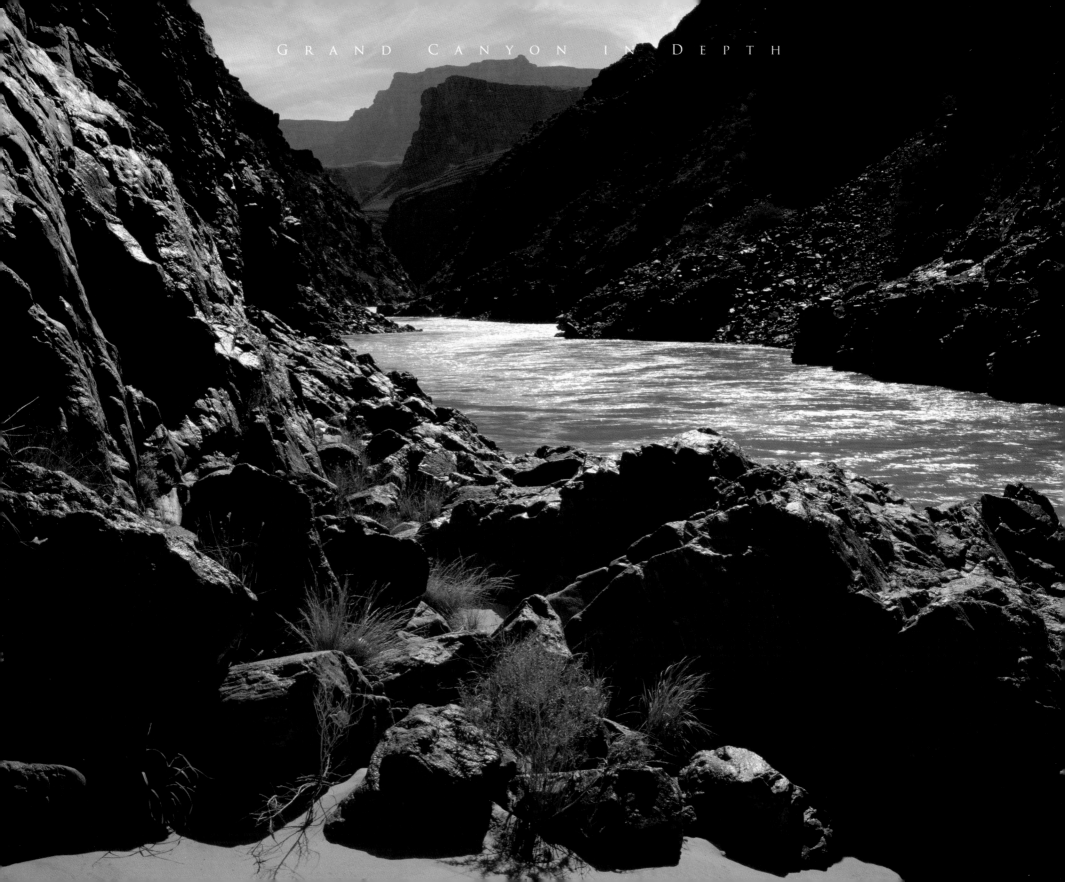

The Inner Reaches

If you are visiting Grand Canyon National Park during the summer, it is probably reasonably cool up on the rims. Most likely, there is shade a few steps away. A cold can of soda or bottle of water may wait for you in your day pack or in your car. From this pleasant aerie on the edge of the canyon you can look down, down, down into an entirely foreign world a mile below.

DOWN THERE, ON THE FLOOR of the Grand Canyon, another reality reigns. If you haven't been there yourself, it is probably difficult to imagine this different world even though it seems to be within spitting distance. The inner canyon looks different, smells different, sounds different, and feels different. It is warmer and drier. Plant life is sparse. Most animals are inconspicuous. The Colorado River elbows its way between soaring cliffs and stubborn crags, but it is often inaccessible to hikers.

And yet, ravishing oases lie hidden in the Colorado's tributary canyons. Streams develop from springs to flow through narrow corridors offering shade, water, and habitat to delicate plants. Some of these special places have wonderful names: Elves Chasm, Shinumo Creek, Matkatamiba Canyon, Deer Creek Falls, Havasu Canyon. River runners stop to explore and enjoy these oases and hikers camp near or within them, while all around them the landscape is arid and harsh.

The inner canyon is an environment of extremes and contrasts. It is beautiful, intimidating, mysterious, hard, idyllic, and, for some people, irresistible.

For those who visit the inner canyon, the outer world is mostly out of sight and largely out of mind. In fact, from the floor of the canyon, the rim is often difficult to identify—a confusion of cliffs guards the canyon's interior, staircasing up and back again and again. And from the intimate, shaded side canyons watered by springs and seeps, even the harsh, sun-flooded canyon fades from mind.

The fragrance of scarlet monkey flowers and the sound of trickling water dominate all.

In the summer, when most visitors experience the Grand Canyon from its high, cool rims, conditions on the floor of the canyon are severe. Daily high temperatures above 100 degrees Fahrenheit (38ºC) are almost guaranteed. In midsummer, especially in the lower elevations of western Grand Canyon, 110 degrees (43ºC) isn't uncommon, 120 degrees (49ºC) isn't unthinkable. The dark rocks of the Granite Gorge absorb the energy of daytime's dazzling sunlight only to release it at night as radiant heat. I've awakened at midnight in western Grand Canyon to find temperatures of 100 degrees (38ºC) or more.

To be an effective and safe Grand Canyon hiker, you must be in good physical condition and knowledgeable about the inner canyon world. Water and shade are your top concerns. Early morning starts, before morning shade is lost and air temperatures soar, are essential. You must carry enough water to make it comfortably to the next water source, but not so much that you squander precious energy carrying it. When you find a stream, soak your head and clothes in it. Evaporation will help keep you cool and, at least for half an hour, transform your experience from difficult to endurable.

The inner canyon deserves great respect. In return, the backpacker is granted intimacies with one of earth's most spectacular landscapes.

Above: A hiker on the Tonto Platform in the inner canyon

Opposite: The Colorado River in the Inner Gorge near Sockdolager Rapid

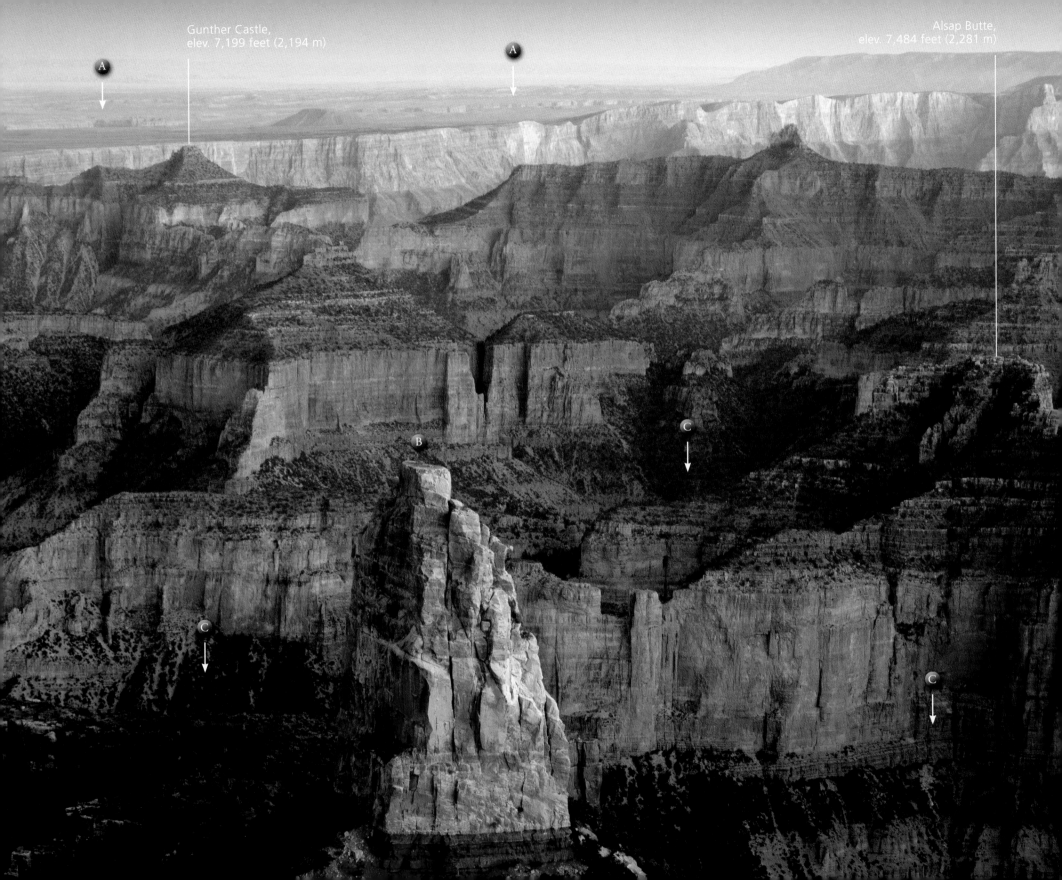

Gunther Castle,
elev. 7,199 feet (2,194 m)

Alsap Butte,
elev. 7,484 feet (2,281 m)

C
↓

Point Imperial

Elevation: 8,819 feet (2,688 m). Looking south at sunrise in July from River Mile 62 to River Mile 70

Dramatic sunrises often visit the North Rim's Point Imperial, the highest point on either rim at 8,819 feet. It was 1932 when a paved road reached Point Imperial and Cape Royal, improving a route first cut through the forest in 1924. Much of the nearby old-growth forest was lost to a fast-moving wildfire in May 2000.

Ⓐ WITH BINOCULARS, look for the rim of Little Colorado River canyon. The Little Colorado River meanders 315 miles (507 km) from the White Mountains in east-central Arizona through the Painted Desert and parts of the Navajo Indian Reservation before flowing into the Colorado deep within the Grand Canyon.

Ⓑ MOUNT HAYDEN, elev. 8,362 feet (2,549 m). This prominent peak was named for Charles Hayden, an Arizona Territory pioneer. The city of Tempe, Arizona, was once known as Hayden's Ferry. Charles Hayden's son, Carl Hayden, served as a U.S. Senator from Arizona from 1927 to 1969. Mount Hayden's distinctive crowning peak is made up of Coconino Sandstone, a common caprock on inner-canyon formations.

Ⓒ NANKOWEAP CANYON. John Wesley Powell named Nankoweap Canyon during his second Colorado River expedition in 1871–72. Nankoweap is a Kaibab Paiute word that means "singing" or "echo canyon." Major Powell, improving upon an American Indian route, supervised the construction of the Nankoweap Trail in 1882. The trail was used by geologist Charles Doolittle Walcott to gain access to an unusual series of strata in Nankoweap Canyon. One of the trail's two trailheads lies about two miles (3 km) north of Point Imperial.

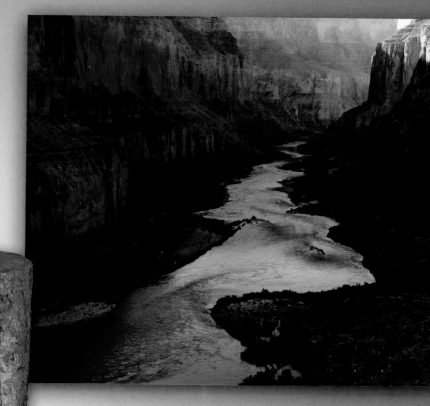

Above: The Colorado River near Nankoweap Canyon to the east of Point Imperial

Inset: Log from a tree inscribed "USGS Survey, Sept. 3, 1880," found near Point Imperial by an NPS fire crew while conducting a controlled burn

Cape Royal ~ 1

Elevation: 7,865 feet (2,397 m). Looking southeast at sunrise in July from River Mile 69 to River Mile 78

Mormon cattlemen once called the Walhalla Plateau "Greenland Plateau" (due to its shape) and Cape Royal "Greenland Point," but the names didn't stick. A section of the unusually large and complex Cape Royal parking area was once an unimproved campground.

Colorful collared lizards are common in the inner canyon. This lizard is perched on a rock near the mouth of the Little Colorado River, northeast of Cape Royal.

Ⓐ THE SAN FRANCISCO PEAKS rise to the summit of Humphreys Peak; at 12,633 feet (3,851 m), it is the highest point in Arizona. The currently dormant volcanic peaks are a little over fifty miles (80 km) away.

Ⓑ CEDAR MOUNTAIN, elev. 7,061 feet (2,152 m). Cedar Mountain is a remnant of younger rock units that have been washed away almost everywhere near Grand Canyon by millions of years of erosion; the formation consists of Moenkopi Formation capped with erosion-resistant Shinarump Conglomerate. The underlying Kaibab Formation, the rimrock of Grand Canyon, is slightly older but is far more resistant to erosion than the shales of the Moenkopi Formation.

Ⓒ COLORADO RIVER. A glimpse of the river from the North Rim is uncommon compared to views from the South Rim. The Kaibab Plateau, through which the canyon cuts, dips gently to the south. The North Rim is therefore higher than the South Rim by about 1,000 feet (300 m), allowing it to capture more precipitation. The plateau's southward dip guides the North Rim's runoff toward the canyon, not away, as on the South Rim. Therefore, the northern side of the river has eroded more, and the North Rim has receded farther from the river, making views of the Colorado from the North Rim rarer.

Ⓓ FREYA CASTLE, elev. 7,299 feet (2,225 m). The peak is capped with Coconino Sandstone, which is about 275 million years old. In Norse mythology, Freya was the goddess of fruitfulness and love. Friday was named after Freya.

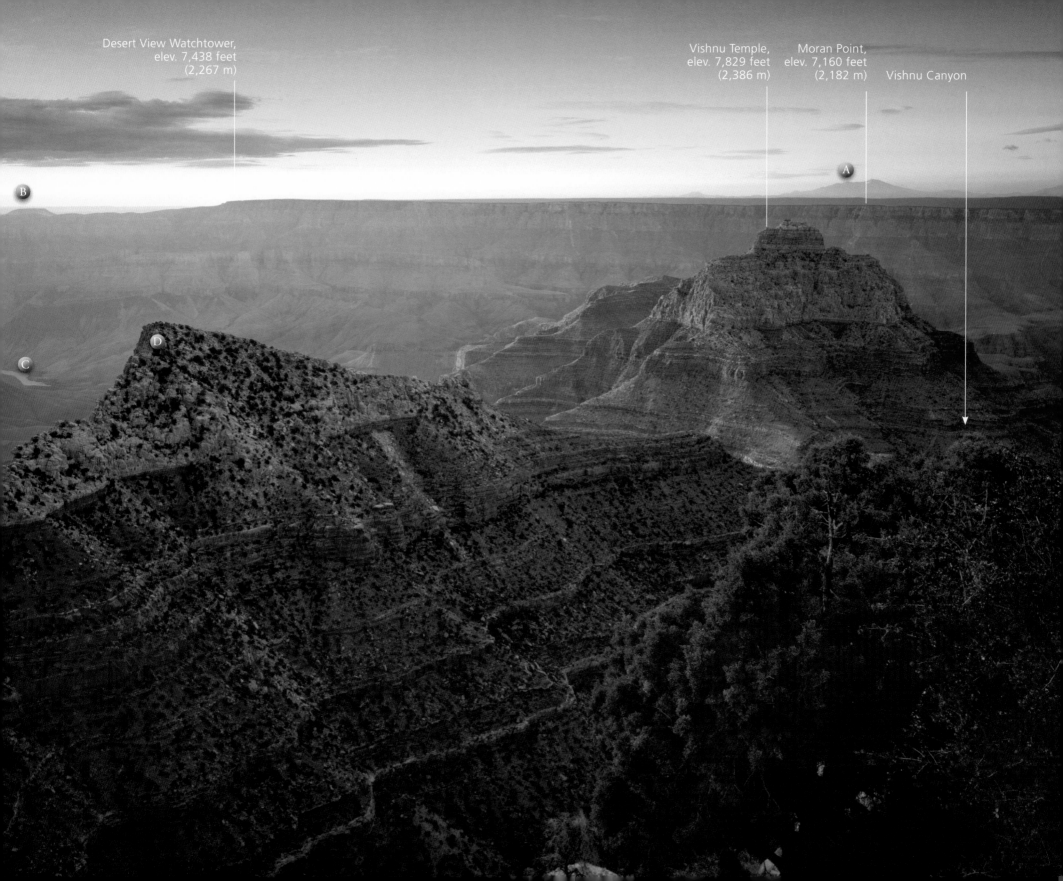

Desert View Watchtower,
elev. 7,438 feet
(2,267 m)

Vishnu Temple,
elev. 7,829 feet
(2,386 m)

Moran Point,
elev. 7,160 feet
(2,182 m)

Vishnu Canyon

Cape Royal ~ II

Elevation: 7,865 feet (2,397 m). Looking south on an August morning from River Mile 79 to River Mile 83

Cape Royal is at the southern tip of the Walhalla Plateau, a large tableland almost entirely isolated from the remainder of the North Rim by the position of Bright Angel Canyon.

A AS YOU LOOK OUT FROM CAPE ROYAL, take a moment to look up at the empty sky. Although the Colorado River has cut about a mile into the plateau below your feet, another mile-thick sequence of rock (that once rested on today's plateau surface) was removed by erosion prior to the cutting of the Grand Canyon.

B FAULTS, FRACTURES, AND FOLDS in the bedrock of a landscape often guide the location and pattern of their drainages: drainages usually follow the trace of the fractured and weakened rock. This is true of many of the canyon's side canyons below Cape Royal. But it's not true of the Colorado River corridor itself. The Colorado cuts across many faults, fractures, and folds. This river does not simply follow a zone of weakened rock to the sea; it's origins are more complex.

C WOTANS THRONE, elev. 7,633 feet (2,327 m), is named after the chief deity in German mythology. The English word "Wednesday" was named after Wotan. Achaeological excavations on top of Wotans Throne in the late 1960s and early 1970s revealed extensive evidence of ancestral Puebloan farming and storage. Although it is possible to climb Wotans Throne, it is extremely difficult (the archaeologists took a helicopter). One of the questions that perplexed the researchers was why these people chose such an isolated, difficult-to-access spot to farm and store food? To date, this question has not been answered.

Above left: The Colorado River meanders through the Dox Sandstone near Unkar Delta. The river to the south of Cape Royal enters an area that is much wider than narrow Marble Canyon to the east of Cape Royal and the Upper Granite Gorge to the southwest.

Inset: The diary of Clement Powell, kept during the 1871–72 John Wesley Powell Colorado River expedition

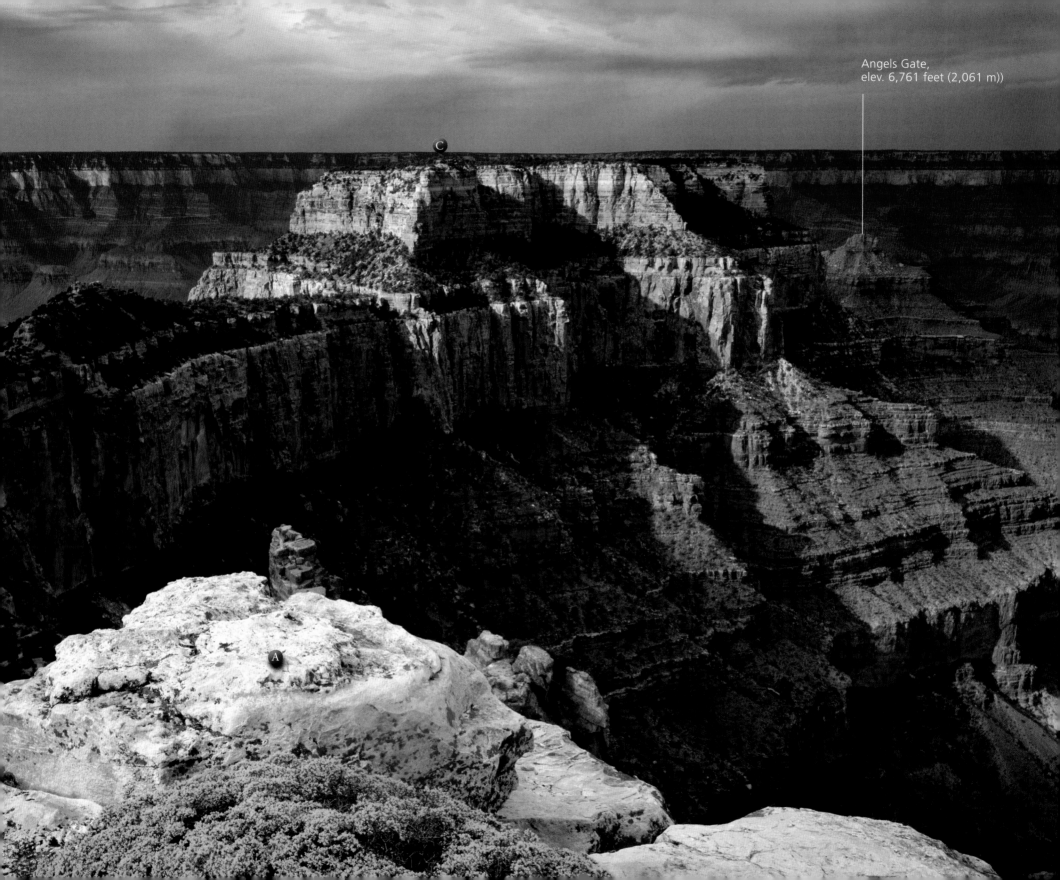

Angels Gate,
elev. 6,761 feet (2,061 m))

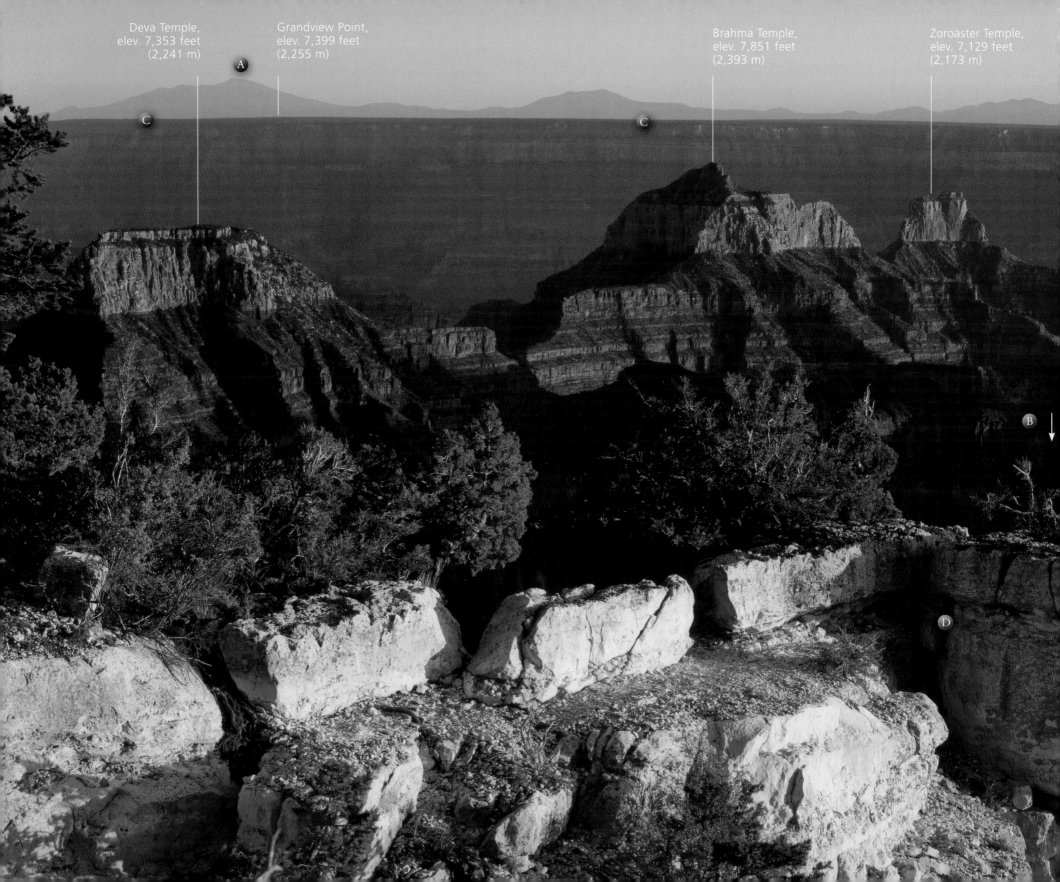

Deva Temple,
elev. 7,353 feet
(2,241 m)

Grandview Point,
elev. 7,399 feet
(2,255 m)

Brahma Temple,
elev. 7,851 feet
(2,393 m)

Zoroaster Temple,
elev. 7,129 feet
(2,173 m)

C

Bright Angel Point ~ I

Elevation: 8,255 feet (2,516 m). Looking southeast at sunset in October from River Mile 80.5 to River Mile 85

The original North Rim Lodge was completed in 1928. But only four years later it was gutted by a devastating fire. Reconstruction of the lodge began a few years later, giving us today's historic lodge with its magnificent timbered dining room and broad patios on the very brink of the canyon.

A **SAN FRANCISCO PEAKS,** elev. 12,633 feet (3,851 m), just north of Flagstaff, Arizona. The earliest eruptions in the San Francisco Volcanic Field occurred about six million years ago near what is today the town of Williams, Arizona. The most recent eruption occurred at Sunset Crater, northeast of Flagstaff, less than 1,000 years ago.

B **BRIGHT ANGEL CANYON.** This tributary canyon of the Colorado River has developed along a fault line that continues southward across the river and up to the rim close to the Bright Angel trailhead. Traversers of the trail, like the side canyon, find it easier to follow the trace of the fault's broken and shattered rocks than the solid rock that lies to either side of the fault.

C **SOUTH RIM.** The Kaibab Uplift, the geologic upwarp through which the Colorado River has cut to make the Grand Canyon, slopes downward gently to the south, leaving the North Rim higher. The differential is obvious when seen from the North Rim—the plateau beyond the South Rim is easily visible. From the South Rim, however, the differential is not nearly so apparent; the North Rim is seemingly at an equal elevation and the plateau beyond the canyon is not within sight.

D **BRIGHT ANGEL POINT.** The panoramic views available at narrow Bright Angel Point are possibly the most spectacular in all of Grand Canyon National Park. A half-mile paved trail leads from the North Rim's Grand Canyon Lodge to the point, which has sheer dropoffs on three sides. The spot has been called the "best place to propose in Grand Canyon," but if considering dropping to one knee and popping the question, make sure that neither the proposer or the proposee is afraid of heights (physical or matrimonial); Bright Angel Point has been known to cause vertigo even in seasoned Grand Canyoneers.

Right: Bright Angel Canyon is home to the majority of the North Kaibab Trail and Bright Angel Creek, a tributary of the Colorado River.

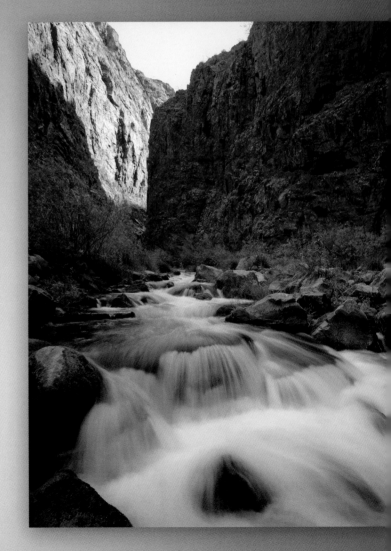

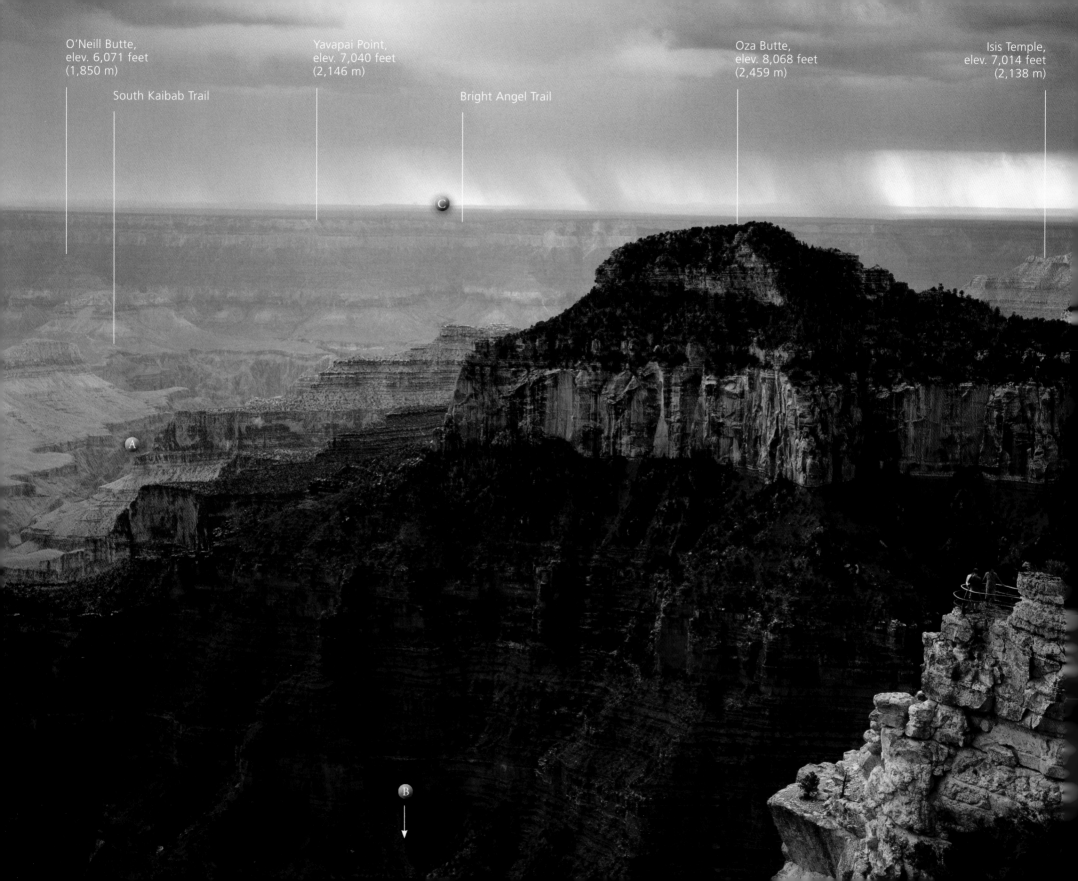

O'Neill Butte,
elev. 6,071 feet
(1,850 m)

South Kaibab Trail

Yavapai Point,
elev. 7,040 feet
(2,146 m)

Bright Angel Trail

Oza Butte,
elev. 8,068 feet
(2,459 m)

Isis Temple,
elev. 7,014 feet
(2,138 m)

Bright Angel Point ~ II

Elevation: 8,255 feet (2,516 m). Looking southwest in the early afternoon in July from River Mile 86 to River Mile 95.5

Like an aerie floating in the trees, Bright Angel Point seems to overlook the universe—Bright Angel Canyon, the South Rim, and an array of temples, points, and ridges.

Ⓐ BRIGHT ANGEL CANYON. John Wesley Powell and his men camped at the mouth of Bright Angel Canyon along the Colorado River during their 1869 expedition down the Green and Colorado rivers. They carved new oars from the driftwood carried down to the head of the canyon by a "clear, beautiful creek." At first, they called it Silver Creek, but Powell soon changed the name to Bright Angel Creek.

Ⓑ THE TRANSEPT. This is a tributary of Bright Angel Canyon, thus a side canyon of a side canyon of the Grand Canyon. Despite its subservience, it's a profound and awesome canyon in its own right. Geologist Clarence Dutton named it in 1882, saying it was "one of the finest and perhaps the most picturesque of the gorges in the whole Kaibab front . . . far grander than Yosemite."

Ⓒ GRAND CANYON VILLAGE. On clear days with high-powered binoculars, you should be able to see Grand Canyon Village nearly due south from Bright Angel Point and the Grand Canyon Lodge. At night, look for the village's lights. The village is ten air miles (16 km) from Bright Angel Point, but it's twenty-four miles on foot via the inner-canyon's trails and 215 miles (345 km) in a vehicle.

Ⓓ GRAND CANYON VISITORS. On average, one to two people die from a fall from the rim annually. The statistics reveal common causes—sidestepping around the guard rails, showing off at the edge for others, losing one's balance when standing up after sitting on the rim, and carelessness when taking photographs and posing for photographs. Most fatalities are men. Children, because they seem to have more common sense than their supposedly clever parents, rarely fall from the rims.

Right: Lupine along the North Rim's Transept Trail. Several species of lupine occur on the North and South rims, particularly during an active monsoon season.

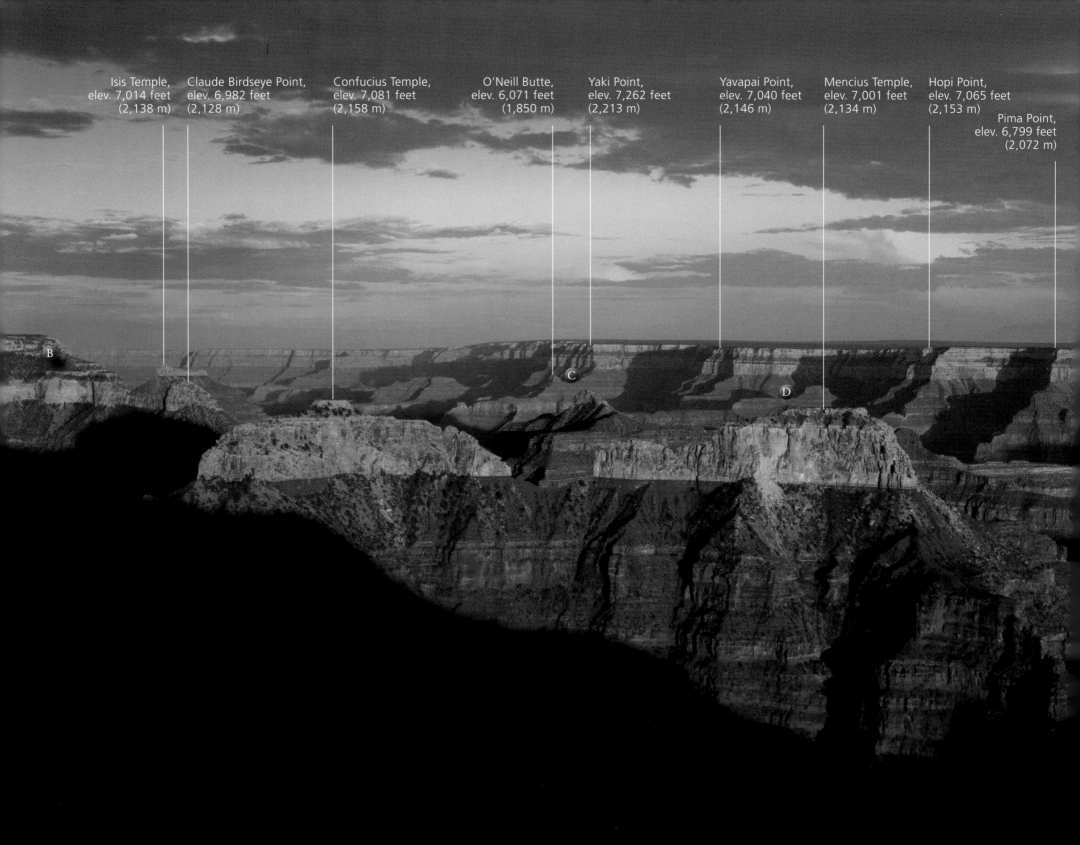

Isis Temple,
elev. 7,014 feet
(2,138 m)

Claude Birdseye Point,
elev. 6,982 feet
(2,128 m)

Confucius Temple,
elev. 7,081 feet
(2,158 m)

O'Neill Butte,
elev. 6,071 feet
(1,850 m)

Yaki Point,
elev. 7,262 feet
(2,213 m)

Yavapai Point,
elev. 7,040 feet
(2,146 m)

Mencius Temple,
elev. 7,001 feet
(2,134 m)

Hopi Point,
elev. 7,065 feet
(2,153 m)

Pima Point,
elev. 6,799 feet
(2,072 m)

Point Sublime

Elevation: 7,459 feet (2,274 m). Looking southeast at sunset in July from River Mile 78 to River Mile 95.5

Traversing the seventeen miles of rough road that lead to Point Sublime usually requires the use of high-clearance four-wheel-drive vehicles. In 1880, geologist Clarence Dutton, the person responsible for much of the epic terminology of Grand Canyon place names, decided that "Point Sublime" was fitting for an overlook of such noble panoramic views.

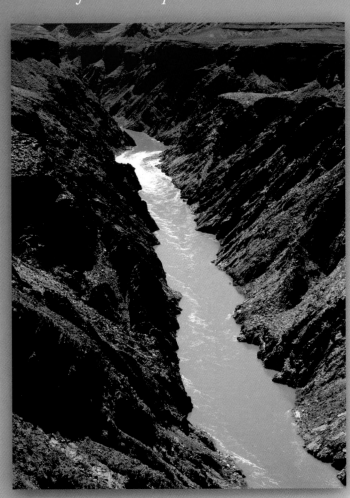

Looking upstream at Boucher Rapid below Point Sublime.

Ⓐ LOOKING SOUTHEAST with binoculars, Boucher Rapid, at River Mile 97, can be seen. It has a drop of thirteen feet (4 m). Like virtually all rapids in the Grand Canyon, it was created by flash floods and debris flows exiting the mouth of a side canyon.

Ⓑ SHIVA TEMPLE, elev. 7,570 feet (2,307 m). An American Museum of Natural History expedition made it to the broad summit of Shiva in 1937. Because erosion severed the Shiva landmass from the North Rim thousands of years ago, it was thought that unique animal species or subspecies may have survived on the isolated plateau. After a mild media frenzy about an anticipated discovery of a family of dinosaurs on top of Shiva, the expedition found no evidence of unknown species. They did find a Kodak film carton purposely discarded by longtime Grand Canyon photographer Emery Kolb, who had been passed over as the expedition's guide and who subsequently scaled Shiva ahead of the expedition.

Ⓒ SOUTH KAIBAB TRAIL. The trail descends 6.3 miles (10.1 km) to the Colorado River and then crosses the Kaibab Suspension Bridge to access the North Kaibab Trail, Phantom Ranch, and, eventually, the North Rim. The trail, built in 1925, is one of the few inner-canyon trails that does not follow an ancient American Indian route. It is also perhaps the only inner-canyon trail to follow a ridgeline over much of its length, providing panoramic views to those who hike it. The trail also serves mule trains, both those carrying tourists from Phantom Ranch and pack mules carrying supplies to and from the bottom of the canyon.

Ⓓ THE BATTLESHIP, elev. 5,850 feet (1,783 m). The Battleship rises above the Bright Angel Trail and Indian Garden. Recently California condors nested in a cave on the west face of The Battleship.

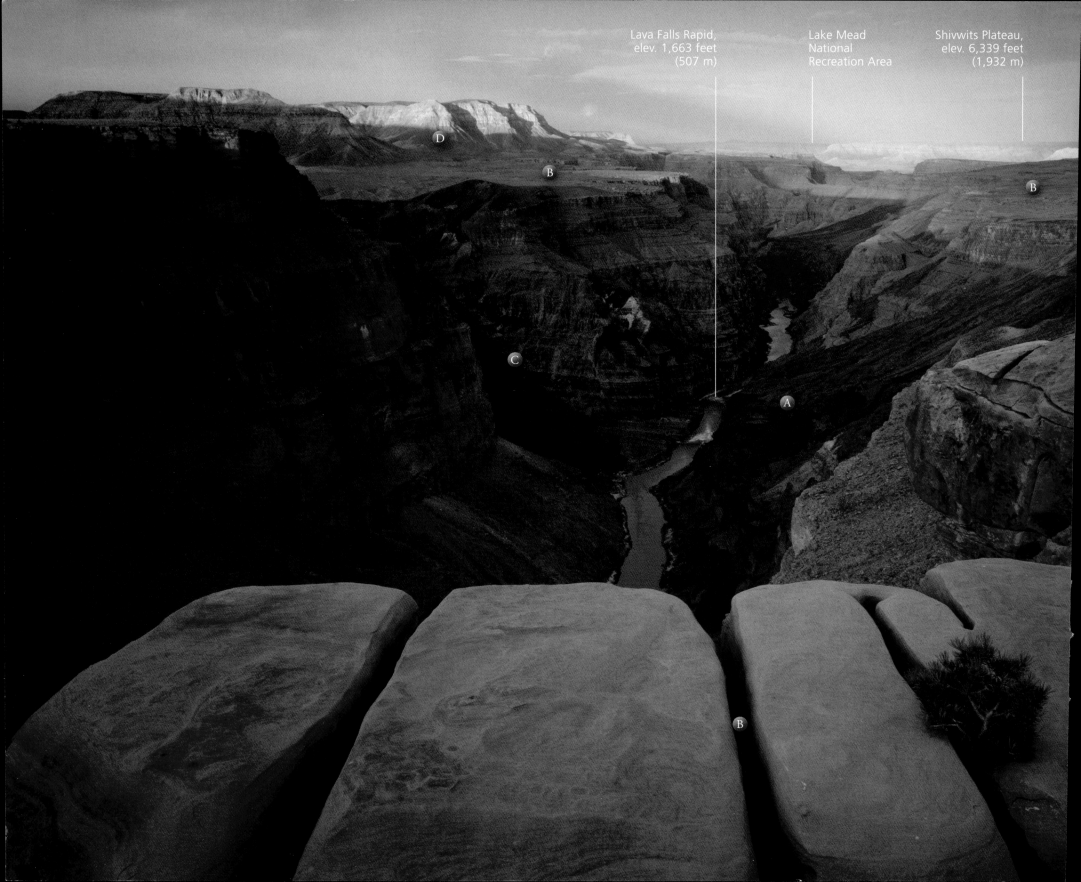

Lava Falls Rapid,
elev. 1,663 feet
(507 m)

Lake Mead
National
Recreation Area

Shivwits Plateau,
elev. 6,339 feet
(1,932 m)

Toroweap Overlook

Elevation: 4,560 feet (1,390 m). Looking west at sunrise in August from River Mile 179 to River Mile 182

"Toroweap" is a Paiute word meaning "dry wash" or "arroyo." Indeed, much of the main road to Toroweap, sixty-one miles of dirt, gravel, and bare rock, crosses a parched landscape of lava flows, cinders, and volcanic vents. It climaxes with views of awe-inspiring lava cascades tumbling from rim to river at road's end.

Ⓐ LAVA DAMS. From about 630,000 years ago to 100,000 years ago a series of volcanoes erupted along this stretch of the Colorado River. At least thirteen of the eruptions were massive enough to dam the river. Evidence suggests that the largest dam reached 2,000 feet (610 m) high or more. (In comparison, Lake Mead's Hoover Dam is 726 feet [221 m] tall.) Although cinder cones and lava cascades are still visible today, the dams are long gone, proof that the Colorado won't allow dams—natural or human-made—to stand in its way indefinitely.

Ⓑ THE ESPLANADE. As you approached Toroweap Overlook from the north, you descended gradually into the Toroweap Valley, most likely unaware of having slipped below the rim of the canyon. Here at road's end you're inside the Grand Canyon, its upper cliffs looming all around. You're also standing on the Esplanade, a broad bench that developed on the surface of the erosion-resistant Supai Group.

Ⓒ THE TOROWEAP FAULT. This major north-south fault crosses the river at Lava Falls. It can be seen just to the left of Lava Falls at the level of the Esplanade, where the downstream (west) side is lower relative to the upstream (east) side. The area's volcanic activity is confined to the region between the Toroweap Fault and the Hurricane Fault, the latter lying about ten miles (16 km) downstream.

Ⓓ HUALAPAI INDIAN RESERVATION. The Hualapai reservation covers more than 1 million acres (400,000 ha) along the south side of the Colorado River, from a few miles east of Toroweap Overlook to Pierce Ferry on Lake Mead. The small tribe (currently with approximately 1,500 members) has been impoverished during most of the years since the establishment of their remote reservation in 1883. In the 1960s, a huge dam was planned for the reservation's Bridge Canyon, 56 miles downstream from Lava Falls Rapid; the resulting reservoir would have flooded Lava Falls, but the plan was defeated after widespread opposition by environmental groups and the general public. Today, the Hualapai Tribe runs raft trips on the Colorado River and operates tourist attractions at Grand Canyon West.

Lava boulders along the Colorado River just downriver from Lava Falls Rapid. The smooth rock has been polished by past floods.

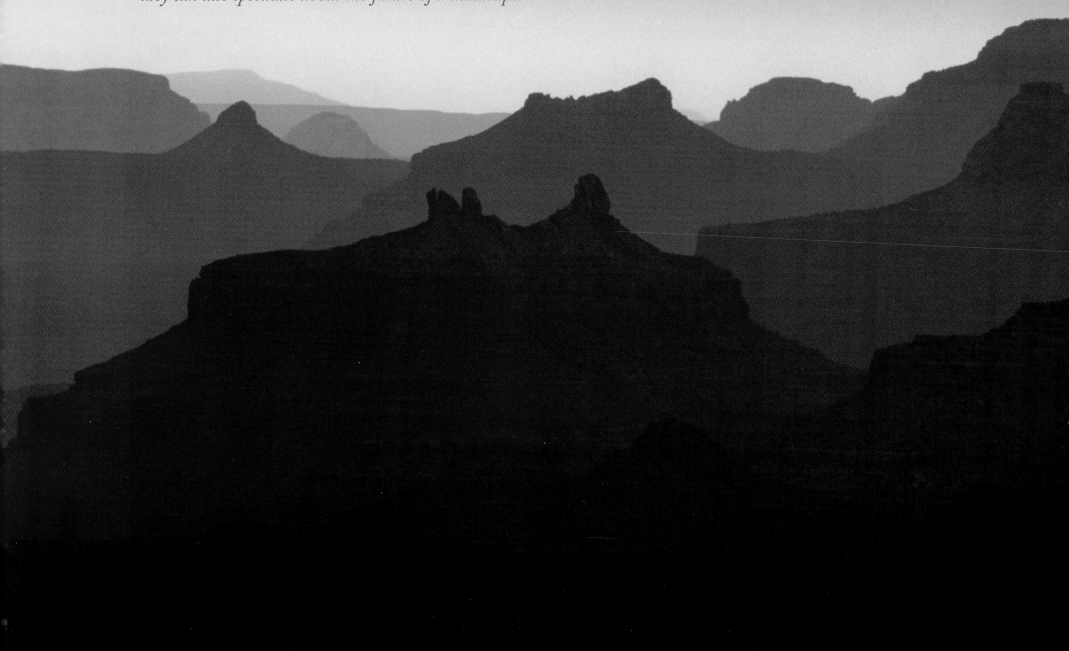

The Future of Grand Canyon

Because geologists can often ascertain what's happened in the past and can see and measure what's happening now, they can also speculate about the future of a landscape.

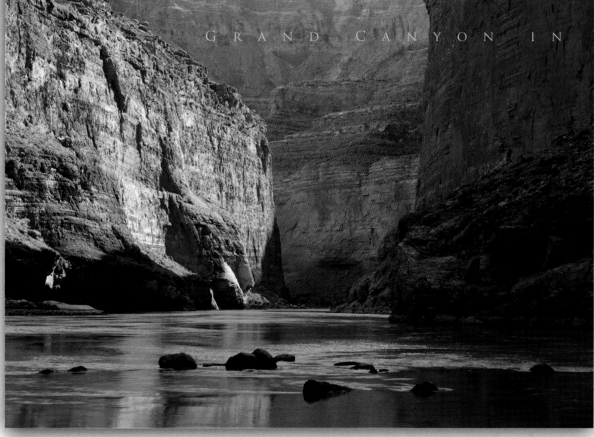

Left: The Colorado River will continue to deepen and widen the Grand Canyon, but such erosion could slow if climate change brings less snow and rain to Colorado, Wyoming, and Utah.

Opposite: Looking west from the South Rim's Desert View at sunset

AT GRAND CANYON WE KNOW that the river will continue to cut downward toward sea level. Also, there's some evidence that much of the plateau through which the canyon has carved is still rising. Given these two facts, we can say this about Grand Canyon's future: The Colorado River will continue to deepen the canyon, and, just as in the past, canyon-widening processes will also persevere.

In several million years, however, the canyon will have become so wide that a visitor standing on one rim will be so far removed from the river and the opposite rim that an appreciation for the canyon's great width will be difficult. The opposite rim will have become a hazy ridge on the distant horizon. Many inner canyon topographic details will also become more difficult to appreciate. The peaks and temples on the north side of the river that we can easily see from the South Rim today, for instance, will have worn down or disappeared entirely. New temples and buttes will have been sculptured from today's Kaibab and Coconino plateaus, of course, but they will be more difficult to grasp because of their greater distance. The future Grand Canyon will look more and more like a wide valley. And if erosion continues unabated, the entire region will waste away until it is near sea level.

Another transformation will occur in western Grand Canyon. Today's canyon ends at the western edge of the Colorado Plateau; when the Colorado River exits Grand Canyon, it enters the Basin and Range Province. The Basin and Range is characterized by north-south–trending fault lines and tilting, mountain-sized blocks of rock between the faults. Think of Nevada's terrain and you'll have a picture of typical Basin and Range scenery.

Geologists have discovered that today's Basin and Range Province seems to be annexing the western edge of the Colorado Plateau, which in the case of the Grand Canyon means the area west of Lava Falls Rapid. The plateaus of western Grand Canyon are not rising as fast as the eastern part of the canyon, and they are in the process of being cleaved by many faults, much like the Basin and Range. And because of the faulting, the cliffs in western Grand Canyon are far more likely to be interrupted by talus slopes and clefts, thus losing some of their grandeur. It is quite possible that in the future, more of Grand Canyon, including the vicinity of Grand Canyon Village, will evolve toward a more Basin and Range type of topography, broken and disrupted by numerous faults.

Climate change, events in the Rocky Mountains that alter the amount of water carried by the Colorado River, and additional episodes of volcanism in and around the canyon could also complicate Grand Canyon's future.

It may be that today's Grand Canyon is as majestic as it will ever be; we may have arrived at its rims at the height of its power to impress our species. But whatever the future may hold for Grand Canyon and ourselves, we can honor the long, slow march toward today's world-class landscape and keep in mind that the future Grand Canyon may be deeper and wider but perhaps not as pleasing to the eye of any aesthetically sensitive beings who come to view it.

INDEX